PENGUIN PLANET
THEIR WORLD, OUR WORLD

TO MAYA AND THEO—IT'S YOUR WORLD NOW.

Published by Taylor Trade Publishing
An imprint of The Rowman & Littlefield Publishing Group, Inc.
4501 Forbes Boulevard, Suite 200, Lanham, Maryland 20706
www.rowman.com

10 Thornbury Road, Plymouth PL6 7PP, United Kingdom

Distributed by National Book Network

British Library Cataloguing in Publication Information Available

Library of Congress Cataloging-in-Publication Data

Schafer, Kevin.
 Penguin planet : their world, our world / Kevin Schafer. -- Second edition.
 pages cm.504 Includes bibliographical references and index.
 ISBN 978-1-58979-791-8 (pbk. : alk. paper) -- ISBN 978-1-58979-792-5 1. Penguins. I. Title.
 QL696.S473S33 2013
 598.47--dc23
 2013012437

Printed in China

··

Early morning among the King Penguins of Gold Harbour, on the magical island of South Georgia. Populations of King Penguins are increasing worldwide, possibly benefitting from a changing climate.

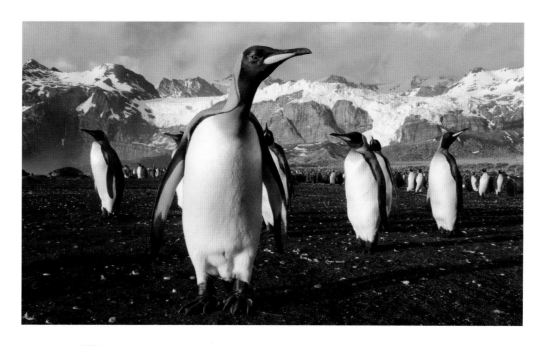

PENGUIN PLANET

THEIR WORLD, OUR WORLD

SECOND EDITION

KEVIN SCHAFER

TAYLOR TRADE PUBLISHING

Lanham • New York • Boulder • Toronto • Plymouth, UK

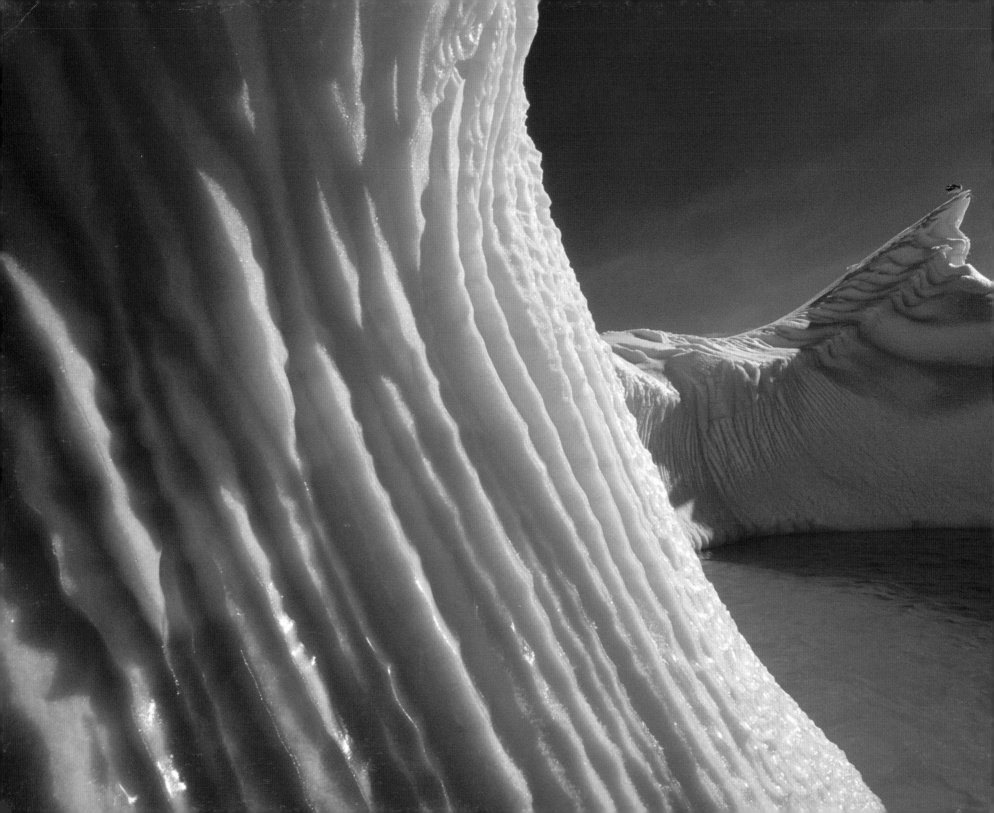

TABLE OF CONTENTS

A sculpted iceberg gleams in the Antarctic sun. Although we think of penguins as polar creatures, many never encounter ice or snow in their entire lives. There are tropical penguins, temperate penguins and penguins that live in dense forests. In fact, only a handful of species is adapted for life in the extreme conditions of Antarctica.

ACKNOWLEDGMENTS

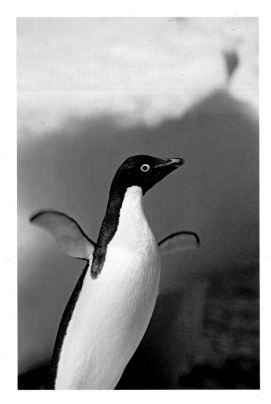

With a sense of jaunty optimism, this Adelie Penguin seems ready to take off and fly. Their white eye-rings, meanwhile, seem to give Adelies a look of eternal surprise.

No one has encouraged, perhaps endured, my love of penguins more than my wife, Marty, who has been with me to most of the penguin places described in this book. And although the cold southern wind does not blow for her in quite the same way that it does for me, she has never flagged in her support of my polar longing. This book, these pictures, could never have been created if it were not for her.

I am also deeply indebted to Sven-Olof Lindblad, President and Founder of Lindblad Expeditions, a leader in Antarctic, and global travel. Sven encouraged my photographic career in its infancy and opened many doors to me over our two decades of association. Many of the images in this book were taken aboard Lindblad voyages in some of the most magical corners of the earth.

In addition, Jessica Cook has made possible our many ventures south by tending the fires at home; I will always be grateful. And finally, this book benefits enormously from the inspiration of my father, Edward H. Schafer, who loved seabirds, but did not live long enough to see penguins in the wild. He, too, would have loved them.

King Penguins do not bother building a nest, but carry their eggs on top of their feet, beneath a flap of warm, bare skin. Changing position, meanwhile, requires a slow, careful shuffle, inch by inch, to avoid dislodging their precious cargo.

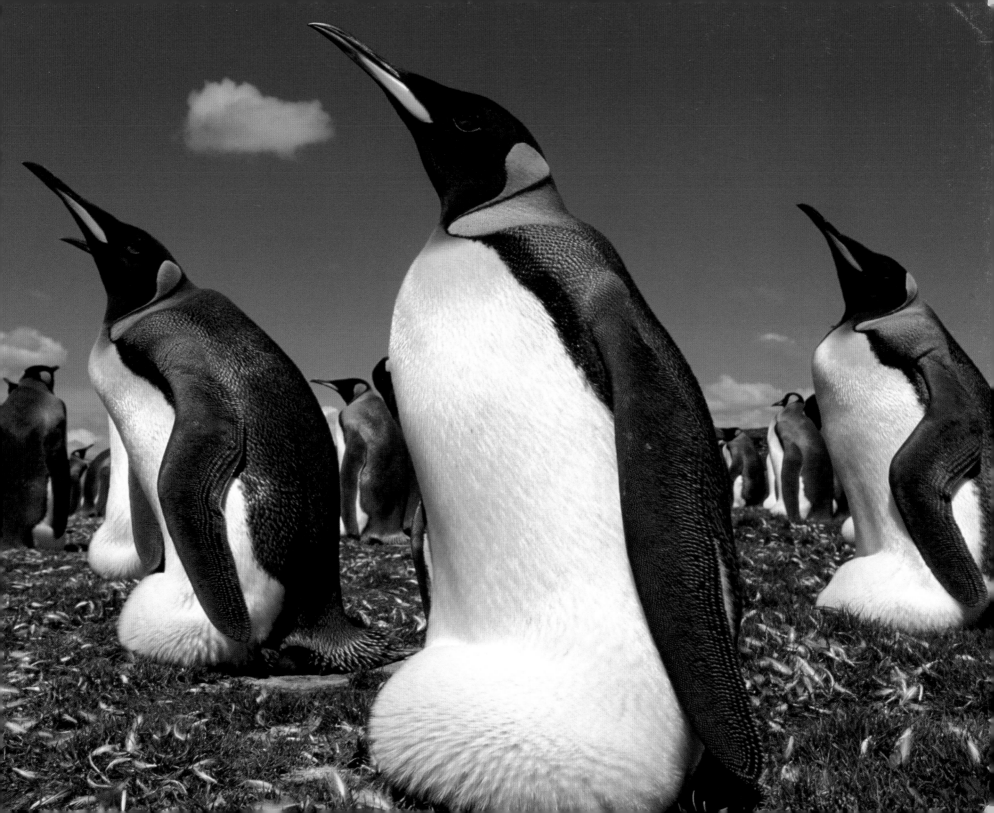

PREFACE

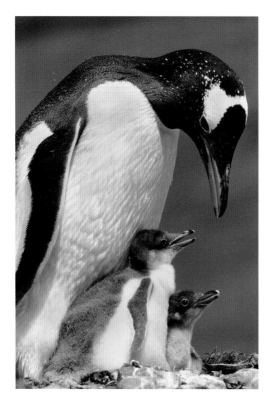

This Gentoo parent keeps a careful eye on its two just-hatched chicks. The quiet boredom of incubation has suddenly been replaced by a steady clamor for food.

My life has been shaped by penguins. They have inhabited my dreams and fueled my longings for distant shores and cold, windswept islands. As a young man, penguins stirred in me a passion for the natural world and nudged me toward a career as a wildlife photographer. They have taught me volumes about the twin miracles of life and evolution, and inspired me with their simple, determined struggle to survive, often under the most difficult conditions imaginable. For all these things, and simply for the fact that penguins exist, I am grateful.

Everyone seems to love penguins and clearly I am no exception. Yet my fondness for penguins is hardly that of a starry-eyed romantic: I have wallowed in far too much guano for that. There remains, even in a hardened naturalist soul like my own, an inescapable delight in their company. For although I have seen penguins at their worst—in the filthy, squabbling chaos of their breeding colonies—I have also seen them at their most sublime, gliding with infinite grace through the endless blue water of the southern oceans.

My obsession with penguins dates to a single, unforgettable day over thirty years ago. I was working at McMurdo Station, the largest US base in Antarctica, where my job consisted of sorting the mail and driving a truck. The mail notwithstanding, I had come to Antarctica for two real reasons; first, because this was as far from anywhere I'd ever been as it was possible to go, and second, because I wanted to see penguins.

I had never seen a wild penguin before, and for two months after I arrived on "the Ice," I never saw so much as a penguin dropping. Then, on a helicopter flight out of McMurdo one afternoon, our pilot noticed a group of Emperor Penguins on the edge of

the ice below. Checking his watch, he announced that we had "half an hour to play" before we had to be back at the station. I couldn't believe my luck.

The pilot gingerly lowered the chopper onto the sea ice—the unnervingly thin, frozen crust that covers the mile-deep waters of McMurdo Sound—bounced a few times to check its stability, and then shut off the engine. To my amazement, a group of twenty penguins strutted right over to inspect us, even before the blades had come to a halt and the engine had stopped its deafening scream. As soon as I slid open the door, the penguins leaned in to see what sorts of creatures we were. They were, as penguins almost invariably are, curious, dumbfounded, and beautiful beyond belief.

I spent the next half hour in an ecstatic panic, madly snapping pictures of every penguin in sight, astonished to find myself in this breathtaking place, surrounded by these proud, regal, and fearless birds. I had hoped that time would stand still for me that day, but half an hour later, I was strapped back in my seat, giddy and overwhelmed, as we lifted off and headed for home.

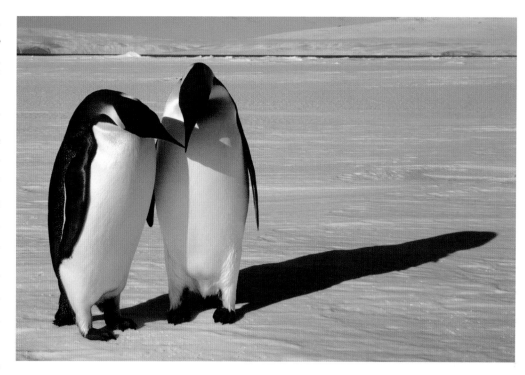

It is no exaggeration that this half hour irrevocably changed my life. Since that encounter on the ice, now so long ago, I have followed penguins all over the world, returning to the Antarctic ten more times, as well as to the many other surprising places where penguins dwell, from the arid, rocky shores of the Galapagos Islands and the rainforests of New Zealand to the sun-swept southern tip of Africa.

Somehow, it became my mission—

My first penguin picture. A pair of Emperors greets one another on the ice of McMurdo Sound with a fanfare of loud, trumpeting calls. Combined with the voices of ten thousand other Emperor pairs, it is one of the most haunting choruses in the natural world.

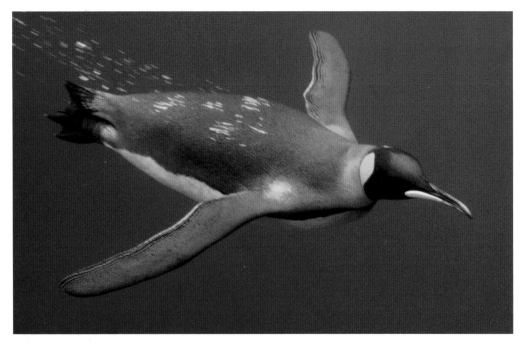

A single King Penguin soars through icy water. No other bird is as perfectly adapted to underwater travel as is the penguin, as much at home in the sea as any seal or whale.

ing struggle to survive—and yes, to their inescapable charm. I have tried to tell something of their story, about how they evolved, how they live today, and what we are learning about them. Inevitably, I must also talk about some of the dangers they face, both from within their natural environment—and from the new threats imposed by the human-dominated world they now inhabit.

The pictures I have included in this book are the result of many years of work and many journeys south. They represent unending hours on airplanes and nauseous weeks aboard storm-tossed ships. Penguins have led me to four continents and dozens of tiny islands—in fact, to some of the most remote, and most spectacular corners of the earth. Needless to say, there remain many places, and many penguins, that I would liked to have seen, but this book, as is so often the case, simply had to get finished.

In the end, I am proud to say that every picture in this book was taken of wild penguins, taken in all the varied places

some called it my obsession—to see, and photograph, every kind of penguin in the world. When my last species, a Fiordland Penguin (one of the rarest and most desperately endangered of them all) finally emerged from the sea on a recent February evening, I was thrilled. And relieved: I had waited on that bug-ridden beach all day to see it.

This book, then, is a personal tribute to the sheer wonder of penguins, to their physical beauty and grace, their inspir-

10

where penguins live. In addition, none of the pictures have been created or embellished on the computer—all represent real events in real places. This is not meant as the last word on penguins—hopefully there will never be one—but as a fleeting glimpse into the richness of their world.

Finally, I feel compelled to defend my choice for the title of this book. How can ours be a "penguin planet," you ask, when penguins inhabit only its bottom half? True enough, I respond, and perhaps my choice of a title represents nothing more than some wishful thinking on my part. I would be thrilled indeed if penguins lived in all the world's oceans, especially the placid waters of Puget Sound outside my office window. But they do not, and why that should be so is just a small part of the penguin story I want to tell.

In the end, however, this question misses the point. The fact is that ours is an ocean world: salt water covers almost three-quarters of it. And beneath the surface of that sea is a place so full of mystery, such an entirely foreign realm of life and experience, that it could well be another planet. We tend to see penguins in our

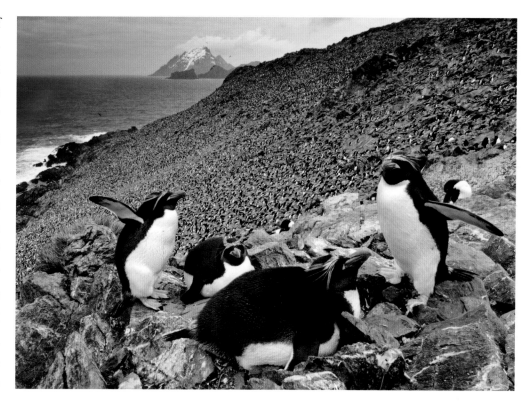

world—in the light and air—but their true home is in the sea. And although a case can be made that fish, or perhaps whales or squid, are the most perfect ambassadors from that watery world, my vote will always be for penguins.

Two pairs of Macaroni Penguins share a small ledge high above the sea on Bird Island, South Georgia. To get to and from the sea, these birds must walk through tens of thousands of other penguins, and *know where they are going.*

AN UNLIKELY BIRD

Penguins are contradictory birds: simultaneously adorable and pathetic, inspiring and hopeless, clumsy and immensely graceful. We are charmed by them, and both amused and delighted in their company. No other bird—possibly no other living creature—evokes such universal affection.

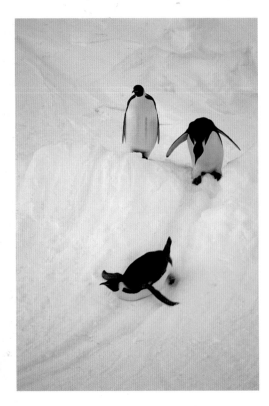

Faced with a slope of steep snow, these Emperor Penguins were quick to decide that sliding was infinitely more sensible than trying to stay upright. There was no sense of play here, no childish joy, just the determined, no-nonsense style that seems to govern the lives of all penguins.

Along the way, penguins have become ubiquitous icons, fashioned into untold thousands of stuffed toys, posters, and coffee mugs. They have become pitchmen for products ranging from refrigerators to ski clothing, cigarettes, and beer. And, most famously, they have lent their name to paperbacks and hockey teams.

Yet our fondness for penguins is somewhat puzzling. What is it about them that we find so irresistibly appealing? They don't have the huge eyes and long fur of creatures like puppies or pandas, animals for which we seem to carry soft spots on the strands of our genetic code. And in the wild, penguins are just about the least cuddly things imaginable. So why do we adore them?

The fact is, penguins are more laughable than lovable. And when we laugh at a penguin, we are really laughing at ourselves. I believe we love penguins simply because they look like miniature, somewhat helpless, versions of ourselves: in other words, like children.

Like us, penguins walk on two legs, a phenomenon surprisingly rare in the animal kingdom. Even our fellow primates only reluctantly travel on two legs; they are much more comfortable on four. No other creatures on earth stand so boldly upright.

A pair of Yellow-eyed Penguins greets one another at the edge of the sea. Thought to be the most primitive of modern penguins, and one of the most endangered, Yellow-eyeds are still the beneficiaries of up to 50 million years of evolution.

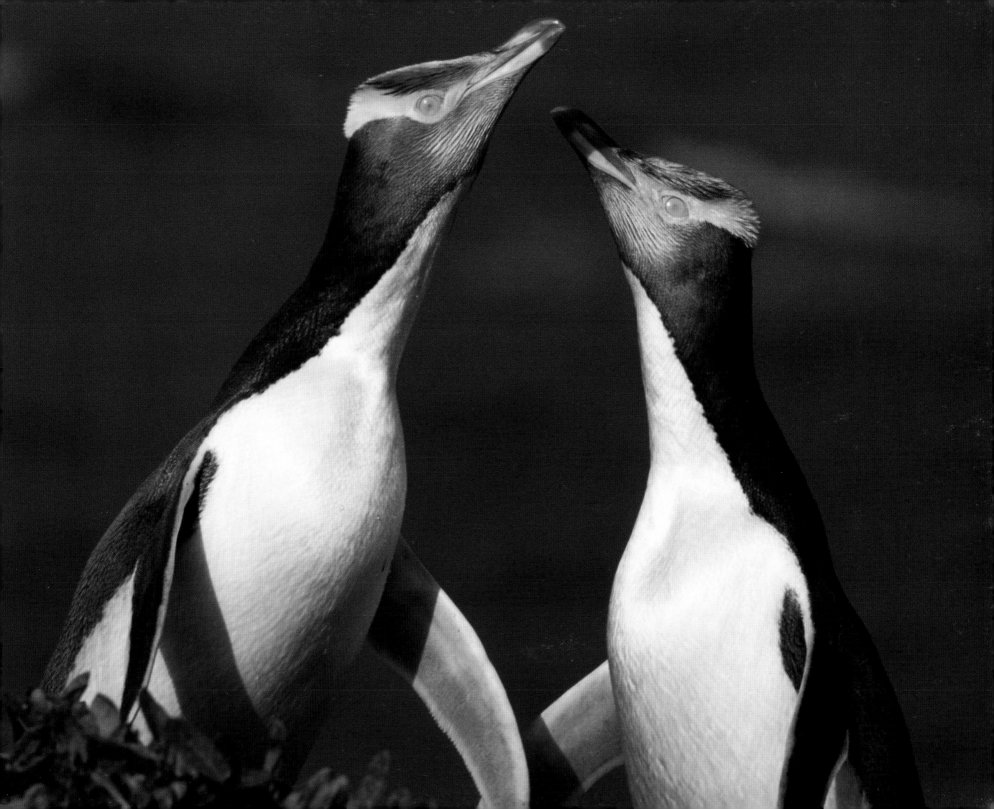

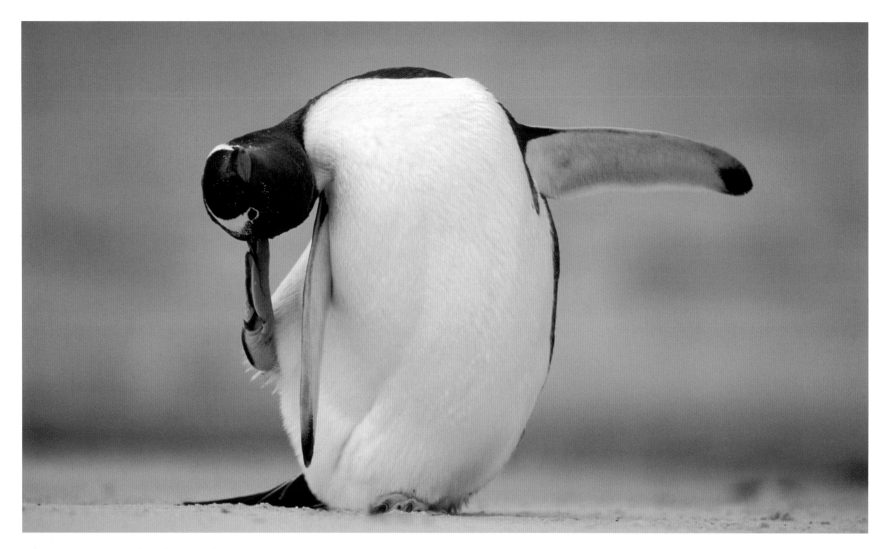

When a penguin returns from the sea, its first priority
is almost invariably to settle in for a good scratch. This
Gentoo manages the task while retaining a remarkable
level of dignity and grace.

In zoos, the sight of a penguin walking invariably evokes peals of laughter. Yet penguins don't simply walk: they scamper, they waddle, they hop, they slide—all with a sense of frantic purpose, like toddlers on a mission. And like children, they evoke in us mysterious urges to love and protect.

I, for one, suspect that Charlie Chaplin had penguins in mind when he gave his character the "Little Tramp" his wobbly, trademark walk. Shrewdly, Chaplin knew his audience would feel for him, as they did for the penguins he mimicked, an irresistible blend of affection and pity.

Clearly, we anthropomorphize penguins more intensely than we do any other creature. We see ourselves in every penguin gesture and every penguin expression. Yet when a penguin enters the water, the comparisons—and the laughter—abruptly stop. Underwater, penguins shed their clown suits and become ballet dancers, creatures as graceful as any on Earth. They are simply, heart-stoppingly, beautiful.

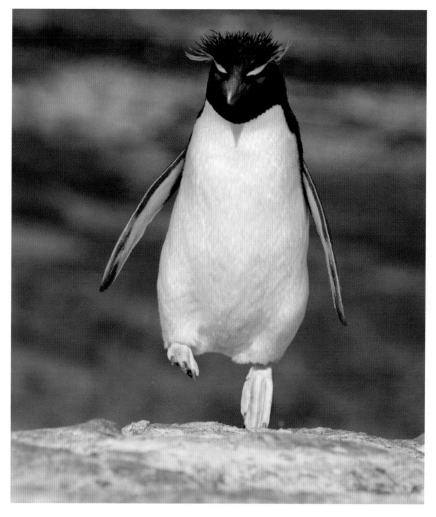

The popular images of penguins today are of relatively recent invention. Penguins were never creatures of myth and legend: the Greeks did not know them, nor did the poets of Rome and their images never appeared on the walls of Stone Age caves. Our first known written record of penguins dates from Vasco da Gama's fifteenth-century voyage around South Africa's Cape of Good Hope. In an entry dated November 25, 1497, at

Living up to its name, a Rockhopper hops along on his way back to the colony after a feeding trip. This simple form of locomotion, so different from the classic "penguin waddle," allows these birds to climb near-vertical cliffs.

15

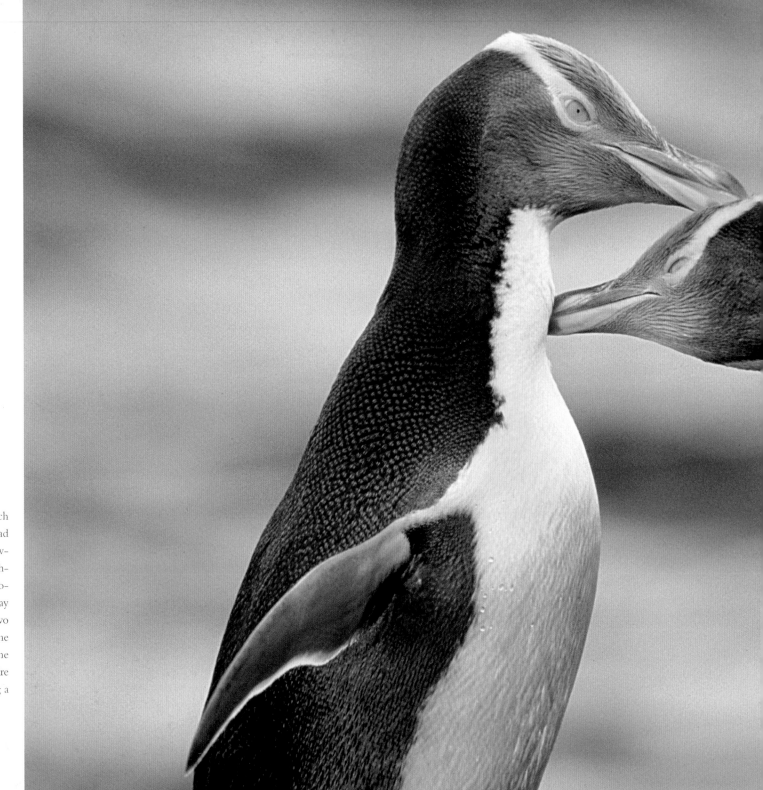

It is hard for a penguin to reach those itchy spots on its own head and neck, so this pair of Yellow-eyeds agrees to help one another—a behavior known to biologists as "allopreening." This may be a mated pair, or simply two unrelated birds sharing the same bit of rock. I once watched one bird work its way along an entire line of other penguins, soliciting a scratch from each in turn.

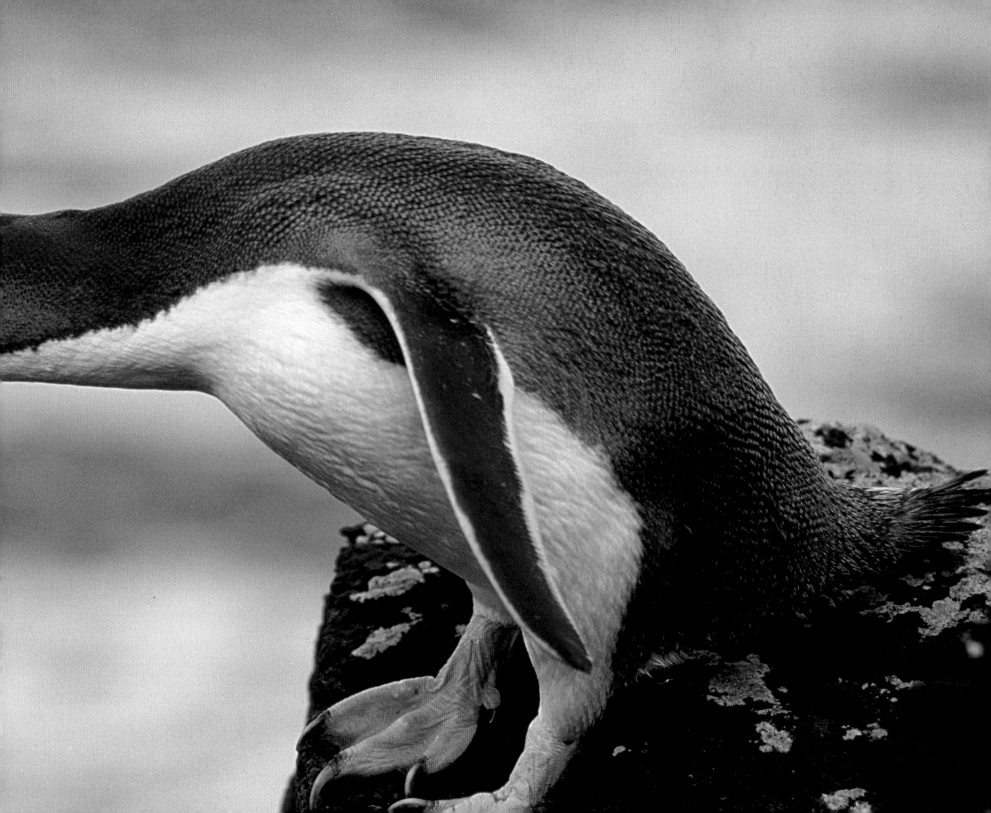

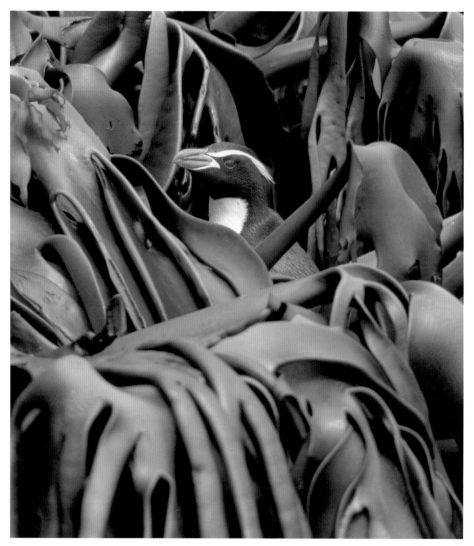

There are times when true wings would be convenient. Thick bands of kelp surrounding the shore made it difficult for this Snares Penguin to get to open water. After struggling to get free, this fellow simply waited for the next wave to gently lift him up and over.

a place now called Mossel Bay, the ship's log describes seeing "birds as big as ducks, but they cannot fly, because they have no feathers on their wings." This remains a reasonably accurate description of the African penguin, a species still found along that coastline today.

But human contact with penguins is almost certainly much older than that. Penguin bones litter the remains of ancient Aborigine camps along the south coast of Australia, a sure sign that they knew penguins and, at least occasionally, ate them. Similarly, native peoples of southern Africa, South America, and New Zealand—places where penguins still live—would have been familiar with several species of penguins. However, no descriptions, written or pictured, have survived to tell their stories.

The origin of the word "penguin" remains obscure, but is generally thought to be derived from Welsh, possibly from the words "pen gwyn," meaning "white head." Inconveniently, however, penguins neither have white heads, nor do they live in Wales. However, there was once another large, flightless bird that could almost certainly be seen in Wales: the Great Auk.

The Great Auk stood 30 inches tall, black and white, and was armed with flippers rather than wings. What's more, it had distinctive white patches on its face. But this was no

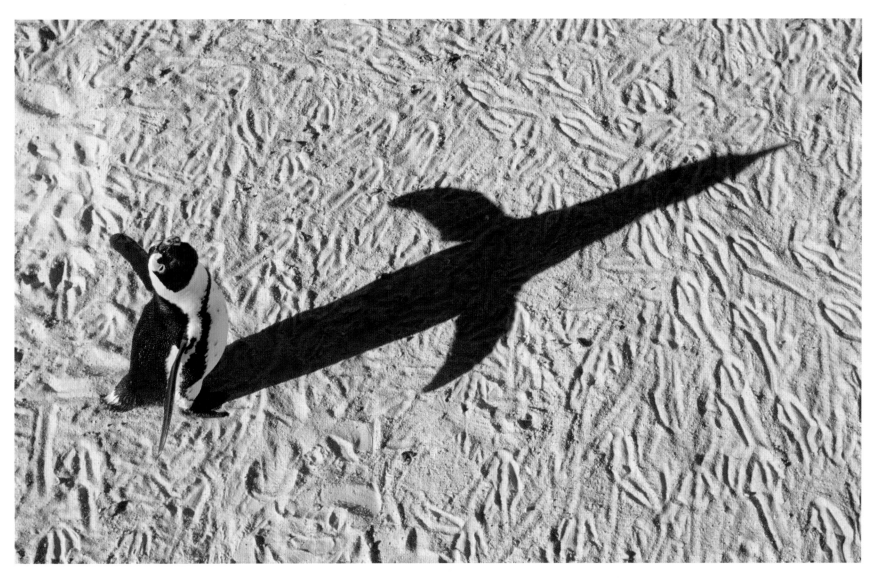

The late afternoon sun casts a shadow that leaves no doubt about the rocket-like design of a displaying African Penguin. All penguins are intensely streamlined, an essential adaptation for reducing drag underwater.

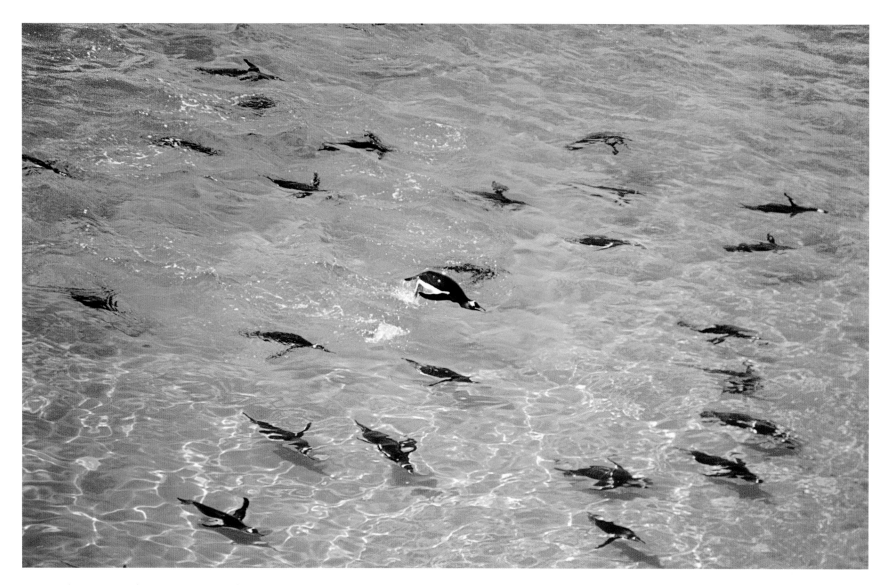

In water almost a tropical turquoise, a group of Gen-
toos returns to shore in the Falkland Islands. Any pity
we may feel for the awkwardness of penguins on land
quickly evaporates when they enter the water.

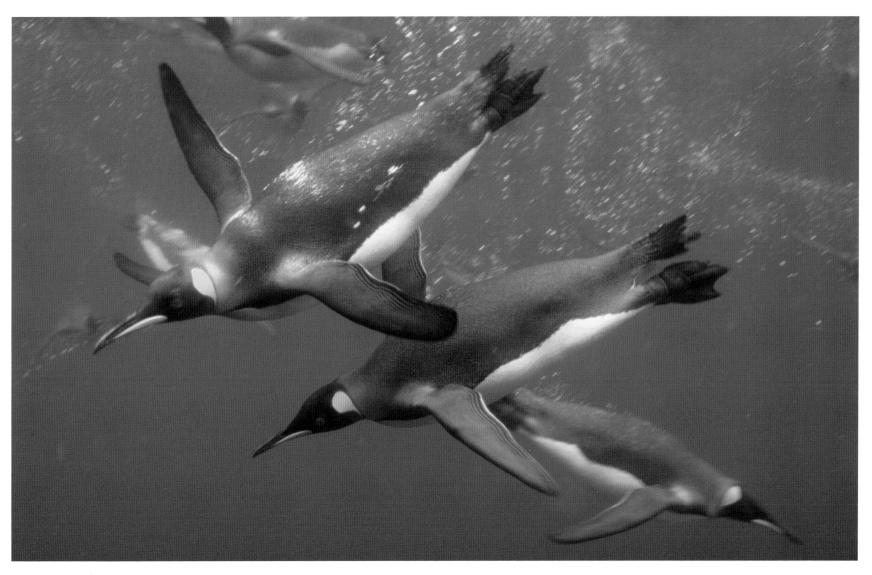

A vision of the penguin's world, as a group of Kings approach my underwater camera with wide-eyed curiosity. True seabirds, penguins spend most of their lives in the open ocean, not in the messy confines of the breeding colony.

penguin: the Great Auk is a member of an unrelated family of birds, the Alcids, of which puffins are probably the most familiar modern members. European sailors knew these birds well—too well as it turns out—and when they first sailed south of the equator, encountering true penguins, they simply used the name of a similar bird that they already knew.

Penguins are exclusively birds of the Southern Hemisphere and remained long isolated from human history. By contrast, and to its great misfortune, the Great Auk lived among the islands of the North Atlantic, within easy reach of the fishing and whaling boats that would eventually prove to be its undoing. Unable to fly, they were slaughtered by the thousands to provide food for passing ships; the bird was already extinct in North America by 1800. The last of the world's Great Auks was clubbed to death on a small island off of Iceland on June 8, 1844.

So although not a true penguin, as we know them today, the Great Auk's place in avian history is marked by its Latin name, *Pinguinus impennis*—which translates from Latin alternately as the "wingless penguin" or "the fat one without feathers." Take your pick.

Penguins are truly ancient birds; their fossils dating back at least 45 million years. They have changed very little since then, which suggests that they were already a very successful group of birds by that time and must have evolved even earlier.

Those same bones also reveal that penguins are descended from flying birds. To those of us who envy the freedom of flight, the idea of relinquishing it would seem an enormous sacrifice, but not to a penguin. For them, the loss of aerial flight was a major step forward, a bold and irrevocable commitment to the sea. The result was that they became the most perfectly designed marine birds that have ever lived.

Several factors may have set the stage for this evolutionary leap. The first was the sheer

Rockhoppers prefer nesting areas with running freshwater, especially if there is a working shower. This penguin defended this little waterfall from other birds for almost an hour, until he'd had enough and hopped away, impeccably clean.

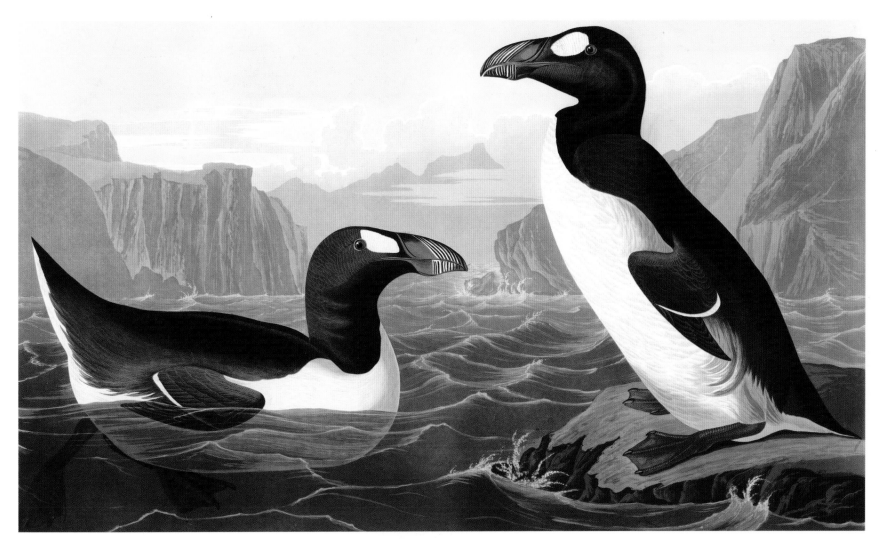

The Great Auk, a lithograph by John James Audubon. This large flightless bird was probably the original "penguin." The last pair was killed in Iceland in 1844: the world is a poorer place for its absence.

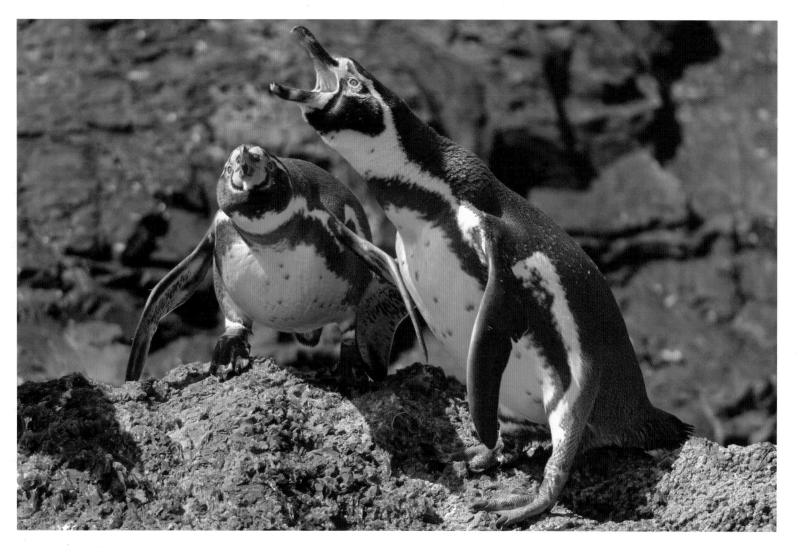

Above: A pair of endangered Humboldt Penguins finds romance—or an argument—on Chiloe Island, in southern Chile. Sometimes it's hard to tell the difference.

Opposite: In the afternoon, Gentoos often storm the beach en masse, leaping out of the water like feathered missiles trying, largely in vain, to land on their feet. They almost never do.

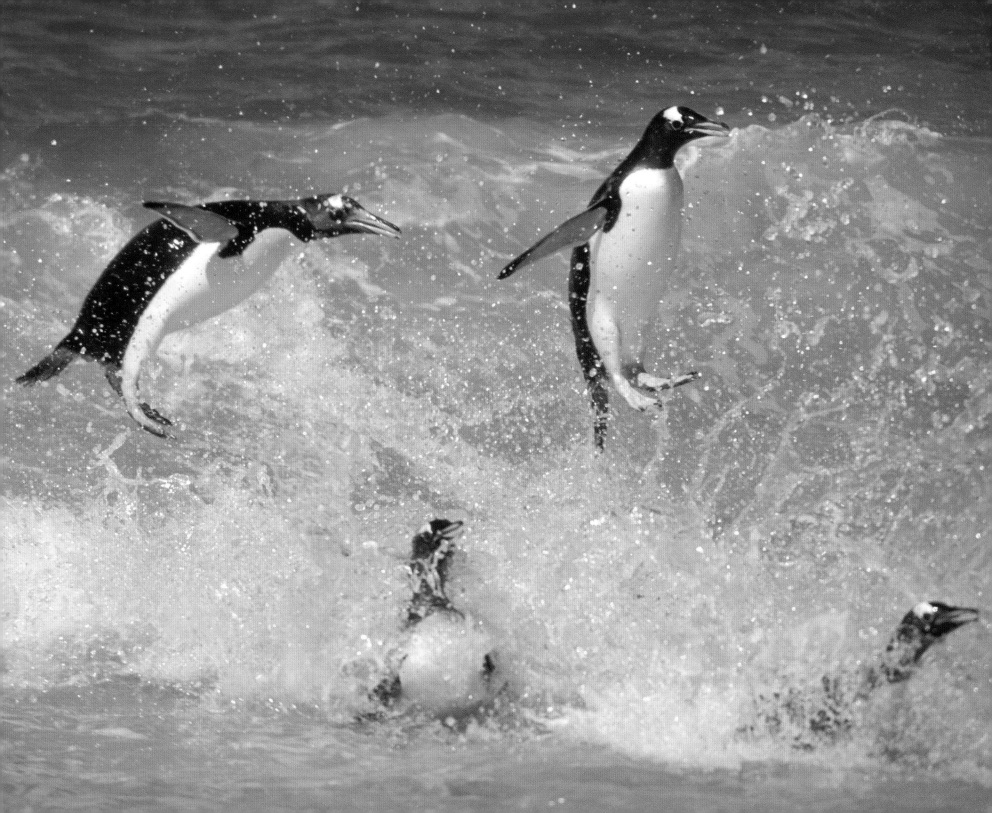

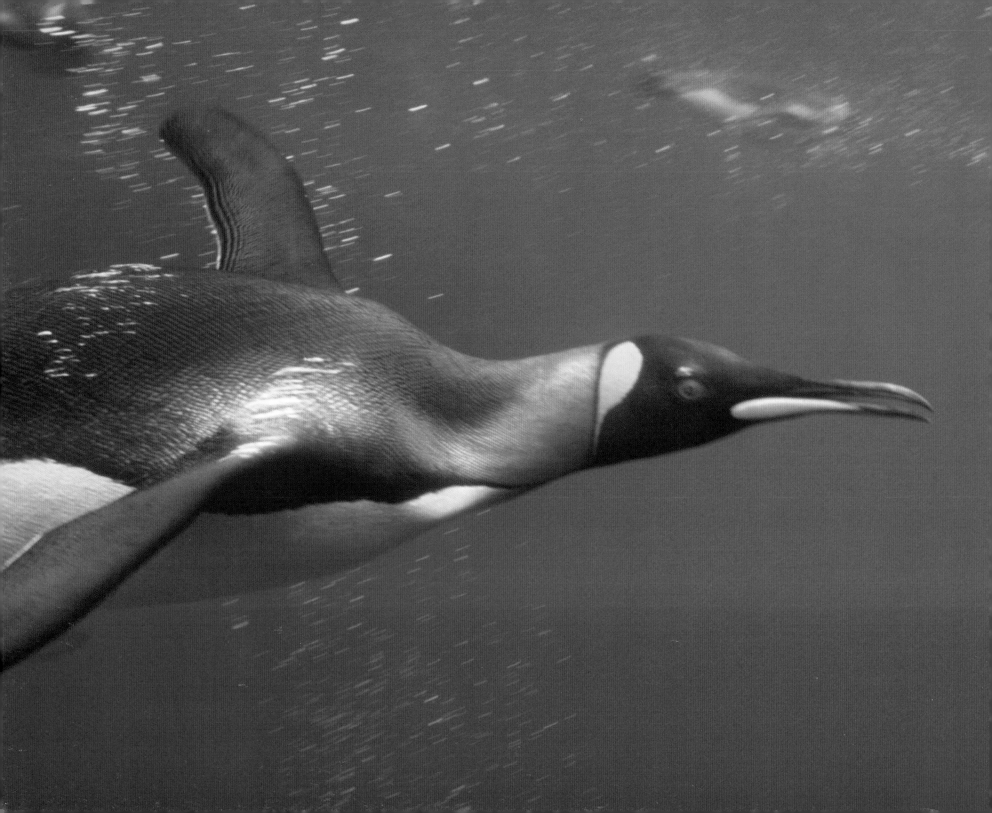

abundance of food in the sea; the southern oceans, where penguins are believed to have evolved, are among the richest on Earth and support an enormous diversity of seabirds. But it's not always easy for a bird—a creature of the sky—to take full advantage of the sea's bounty. Most seabirds catch their prey by diving, plunging into the sea from above, hoping to grab a fish or squid before bobbing back up to the surface. But this technique gives a diving bird access only to the top few meters of the water; anything below that is out of reach.

And while there are a handful of seabird species that can actually pursue their prey underwater, either by crudely flapping their wings or by kicking their feet, none of them could fully exploit the riches of deeper water. This left an opportunity for penguins. But to take full advantage of that opportunity, penguins had to give up the

A penguin's eyes must be able to focus underwater as well as on land–something that our eyes cannot do. They accomplish this with special eye muscles that can change the shape of their lenses to adapt to these different visual environments.

ability to fly, and this would not have been possible without another abiding accident of history: a lack of predators.

Penguins evolved in the temperate seas of the Southern Hemisphere, probably in or around New Zealand, which even today can boast of having the highest diversity of both fossil and living penguin species of any place in the world. And despite their aquatic nature, penguins are still tied to the land; every year they must come ashore to nest and lay their eggs. Inevitably, this makes them—and their eggs—vulnerable.

In the Arctic, foxes regularly prowl seabird colonies and live off eggs and young birds. To avoid them, nesting birds escape onto sheer cliffs, beyond the foxes' reach, or hide their nests in deep burrows. Here, giving up the ability to fly would be tantamount to suicide. Only the Great Auk, which lived only on isolated islands beyond the reach of predatory mammals, managed to pull it off—at least until humans came along.

But foxes never made it to the remote islands of New Zealand, and without them,

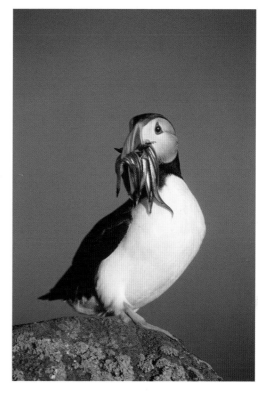

This Atlantic Puffin looks much like a penguin, although it is unrelated. They share the same black and white coloration, and feed underwater for fish, like these sandeels. Yet the puffins and their kin, found only in the northern hemisphere, have not relinquished their ability to fly.

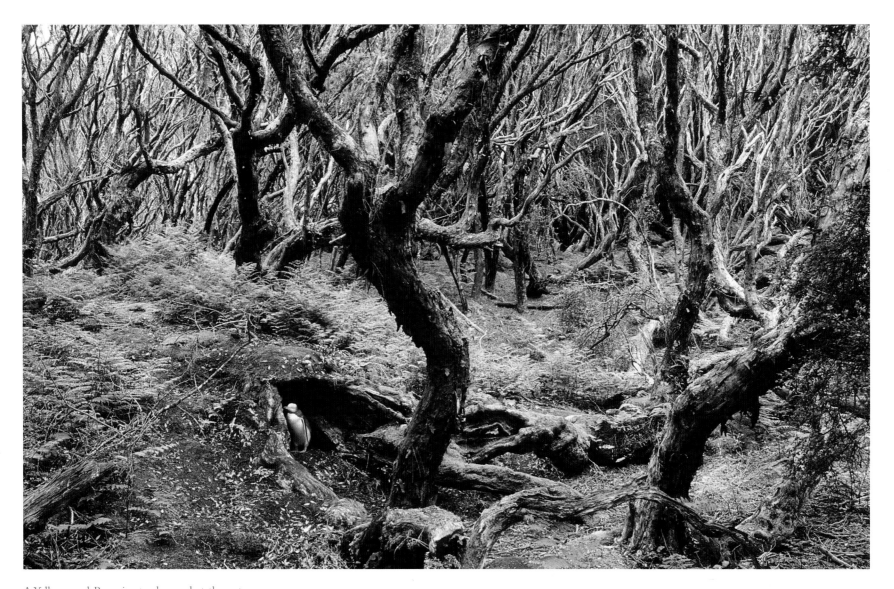

A Yellow-eyed Penguin stands guard at the entrance to its nest burrow on Enderby Island, surrounded by native rata forest. Only in New Zealand, which has more penguin species than any other country, do penguins nest in dense forests like this—what little remains intact.

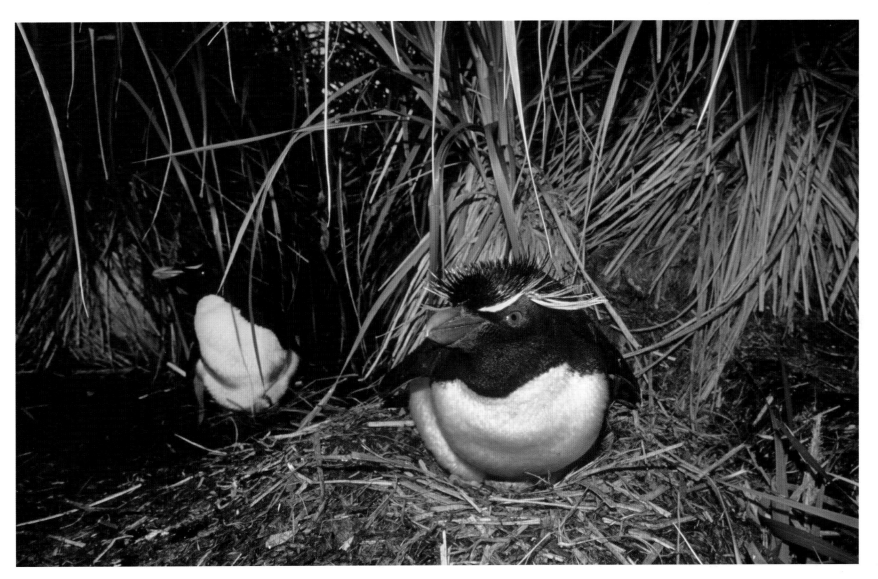

A Rockhopper incubates an egg on the floor of a tussock grass "forest" in the Falkland Islands. More than a third of the world's population of these pint-sized penguins lives in the Falklands, making it a vital refuge for this threatened species.

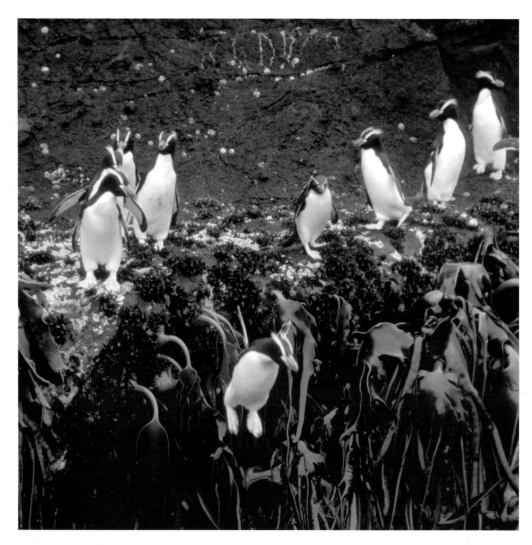

For these Erect-Crested penguins, returning to the sea at low tide requires a Hail-Mary, feet-first leap into the water. Found only on the remote Bounty and Antipodes Islands of New Zealand, these are among the most difficult penguins in the world to see.

or any other mammalian predators, penguins simply had no need to fly. Suddenly, they were freed from the constraints imposed on flying birds: they could nest on the open ground, and grow both larger and heavier as their bodies adapted to life in the water. In this new, dense medium, the penguins' wings became flippers and their feet migrated back to their tails, out of the way.

In short, penguins flourished—and continue to do so. By any measure, penguins represent an evolutionary success story; with a design this good, there hasn't been much incentive to change. They spread throughout the southern oceans, and diversified into the striking variety we see today.

There are seventeen species of living penguins in the world—more or less. I equivocate only because there is surprisingly little consensus on the subject.

Nothing in the natural world can compare with the flood of sensations experienced in the middle of a King Penguin rookery on South Georgia Island. The noise, smell, and constant activity can be overwhelming.

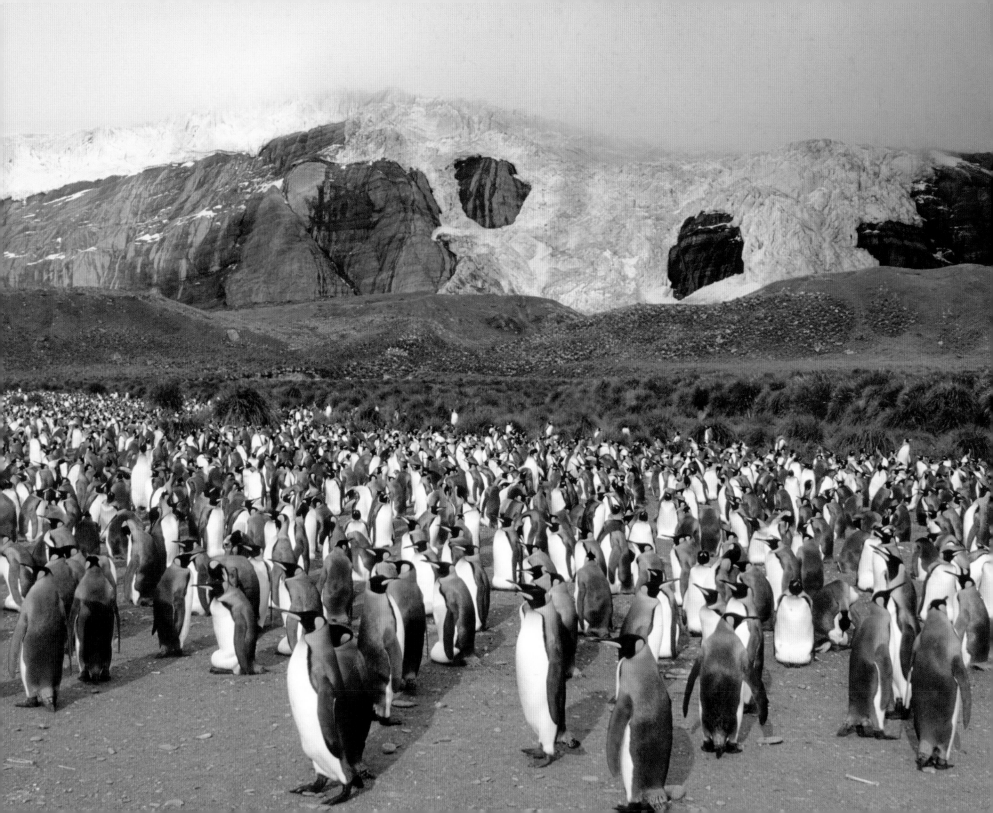

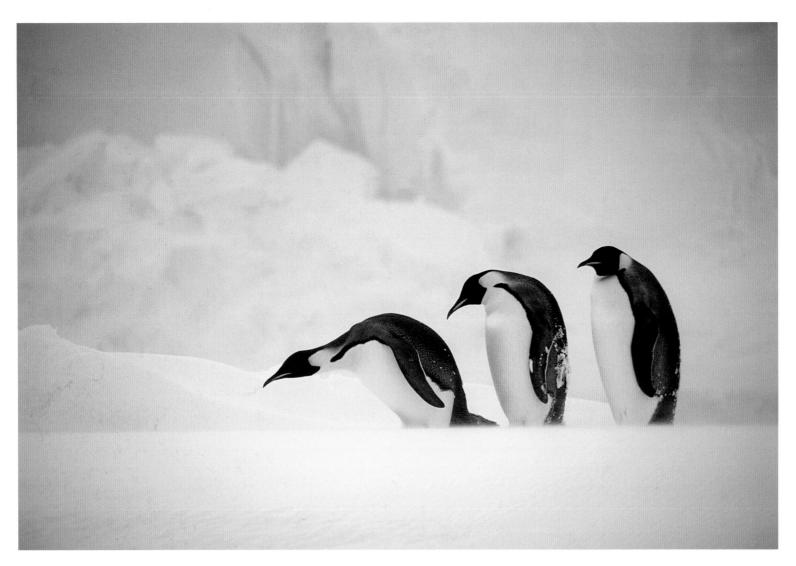

Largest of living penguins, Emperors are designed
for the harshest conditions of any species, breeding
in a world of perpetual ice and snow. Large as it is,
however, the Emperor would have been dwarfed by
several species of extinct penguin giants.

The number seems to range from fifteen to about twenty-one, depending on whom you talk to, and what you believe. These varying numbers do not reflect the discovery of any new species (a potentially thrilling but unlikely event) but simply different ways of looking at the penguins we already have.

Penguins are far-flung creatures, breeding on islands and shores all around the Southern Hemisphere. In some cases, a single species may vary considerably across its range—larger in some places, smaller in others—or with varying adornments or social behavior. Some scientists would place these isolated populations into separate species while others live happily with the notion of local variation. (For the purposes of this book, I will ignore controversy and stick to the widely accepted number of seventeen.)

Many people are surprised to learn that there are so many penguin species in the world. Only a handful of these generally make it into zoos or wildlife films, while the rest live in relative obscurity. Few people have ever heard of them and even fewer have ever encountered them in the wild.

Consider the Erect-Crested Penguin, a handsome tufted species that lives only on two tiny island groups off the southern tip of New Zealand, the remote Bounty and Antipodes. It may be that no more than a few hundred people have ever seen these penguins. And who's ever heard of the Snares Penguin, or the Fiordland for that matter?

Despite their diversity, all penguin species are vastly more alike than they are different: it would be impossible to mistake one for anything else. They are variations on a theme: all are stout-bodied and heavy-boned, with rigid flippers instead of wings. They are usually some combination of black and white, walk more or less upright on land, and swim with the elegance and ease of a fish. Their feathers are small and densely packed—more so than those of any other bird—and provide 80 to 90 percent of their insulation, both in and out of water.

Penguins vary most noticeably in size, from the well-named Little Penguin of Australia and New Zealand—standing only 18 inches (45 centimeters) high and weighing just over 2 pounds (about 1 ki-

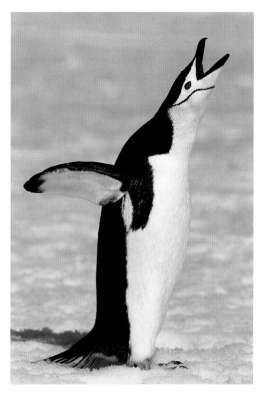

A male Chinstrap Penguin in the South Sandwich Islands performs his so-called ecstatic display, an expression of his enthusiastic willingness to breed. This display—or one like it—is common to all penguin species.

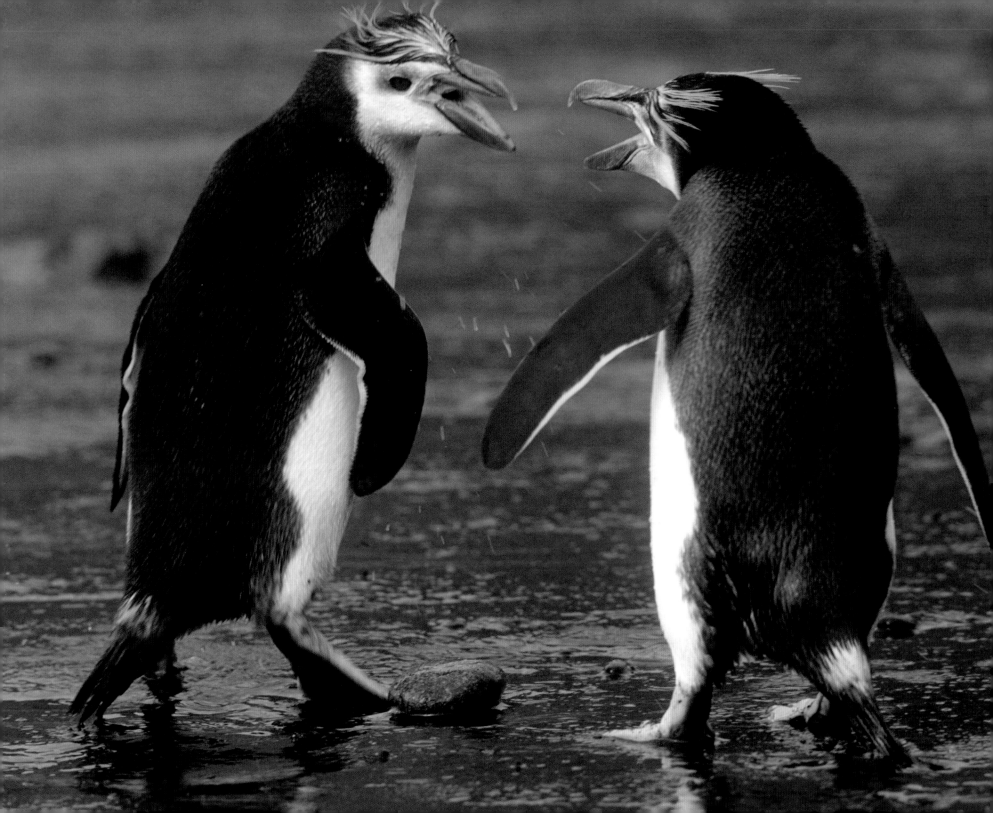

logram)—to the mighty Emperor, more than twice as tall, with a weight of up to 90 pounds (41 kilograms).

Penguins also vary in behavior and—at the risk of further anthropomorphism—in "personality." Emperors and Kings, largest of the tribe, seem slow and deliberate while Adelies, by comparison, are hyperactive. Rockhoppers seem particularly prone to argument, while Magellanics seem unreasonably fond of their own loud, braying voice. (We all have our favorites: mine will always be Emperors.)

Two Royal Penguins square off on a Macquarie Island beach. Such fighting—over partners, territory, or any of a list of penguin offenses—is an unavoidable part of colonial life. The sound of these arguments punctuates the breeding colony both night and day.

There is also considerable variety in the kinds of places where penguins live. While the penguins of our imagination live in the Antarctic, in reality most live far from the world of permanent ice and snow, preferring more temperate shores. You may be surprised to learn that

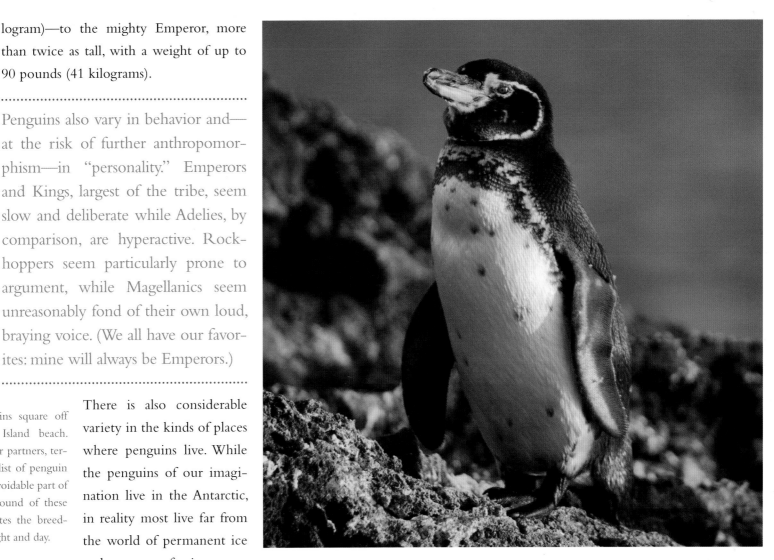

The only species found on the equator (or anywhere near it), the Galapagos Penguin is closely related to cousins farther south, and was likely swept north on the cold, Humboldt Current.

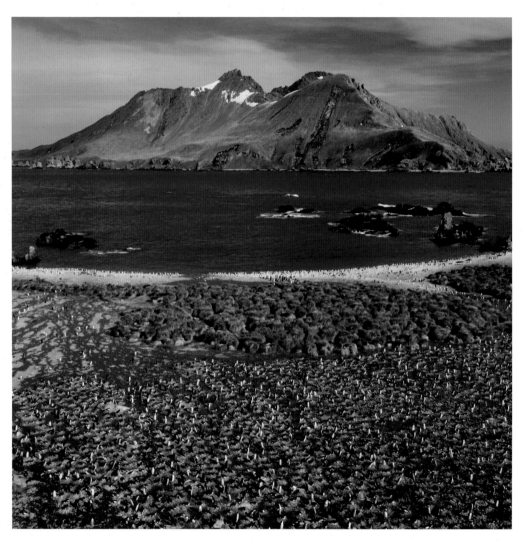

Cooper Bay, at the south end of South Georgia Island, is home to a small colony of Chinstrap Penguins, a species generally found much farther south along the edge of the pack ice.

penguins are found in the windswept desert coasts of Argentina and Peru, among the dense rainforests of New Zealand, and in the case of one species, the Galapagos Penguin, right on the equator.

No penguins, however, inhabit the Northern Hemisphere, a fact that provides further evidence that penguins evolved in the southern oceans and simply never left. Most likely the warm water of the equatorial belt created an impassable barrier to northward travel, and since food was so abundant in the south, there was no reason to go elsewhere. So penguins stayed in the south, and thrived.

A penguin colony is a gathering place, but also a bedroom. After a long feeding trip at sea, the first thing a King Penguin wants to do when it gets home is take a good, long nap. These two birds spent most of an afternoon rocking on their heels dreaming, perhaps, of endless shoals of squid.

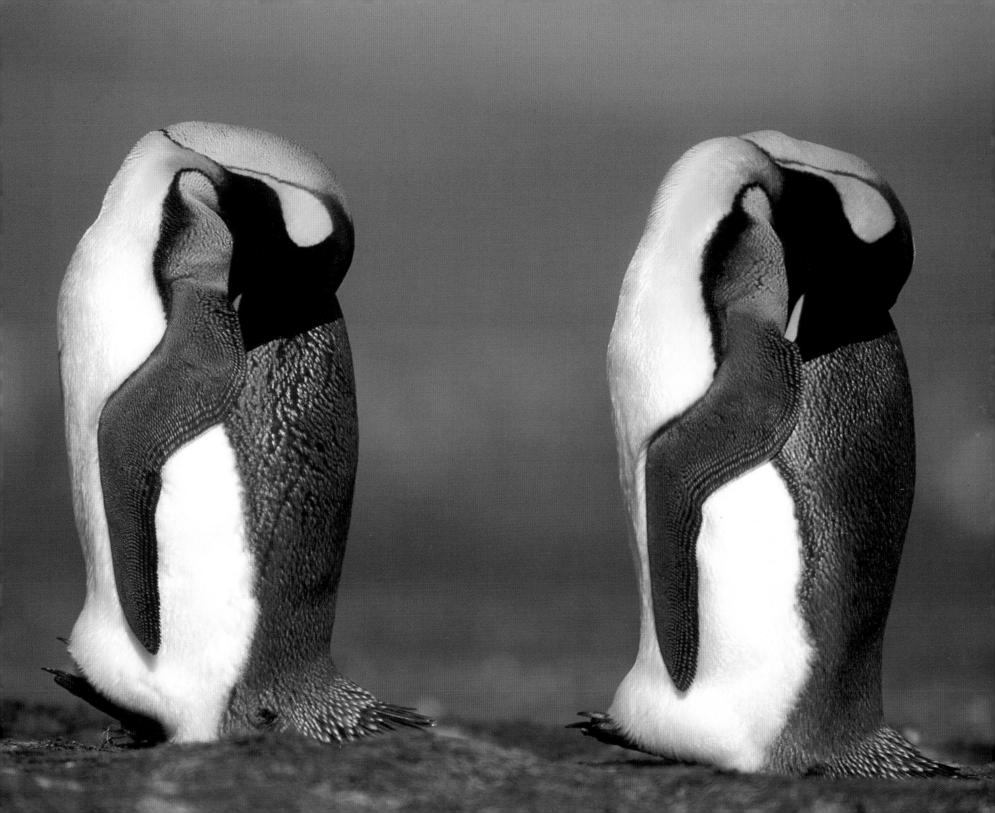

BUILT TO LAST

It would be hard to improve on a penguin. I cannot think of another animal that so beautifully displays its marriage of form and function, of engineering and aesthetics. The penguin has raised flightlessness to a new art and done things no bird has ever done before.

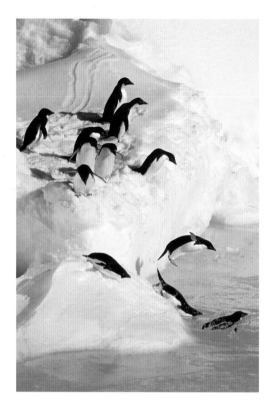

Penguins are built for life in the water, so getting around on two feet can sometimes be challenging. Creativity was clearly required by this group of Adelies trying to cross some broken ice in the Ross Sea. Jump, fall, slip, and slide: these are pretty much the options available.

Among the first things you notice about a penguin is its shape: fat in the middle and tapered at both ends. Not a particularly efficient design on land—try standing a cigar on its end—but perfection itself in the water. Yet although a penguin on land may look as though it could topple over in a stiff breeze, it is actually very stable. To see why this is so, look at a penguin's legs—what little ones it has.

A penguin actually rests atop its lower legs, the upper legs completely enclosed within its body. What's more, the bones of those upper legs are oriented horizontally and are very short. The point of all this is to position the penguin's leg directly under the middle of its body, allowing it to stand vertically in a way that no other bird can duplicate. The result is an upright, walking bird with no knees, the cause of its distinctive, wobbly gait.

The fact is, a penguin is a masterpiece of design compromise. With a body contoured like a torpedo, getting around would seem an awkward anomaly. And although we think them clumsy, penguins are surprisingly accomplished on land. They climb mountains, scale sheer cliffs, and walk dozens of miles: feats beyond the reach of any other birds.

A Chinstrap Penguin seems to point the way to the colony, but is more likely just having a stretch. The pink flush to his flippers suggests he has just come out of the water. Within a few minutes that color will fade.

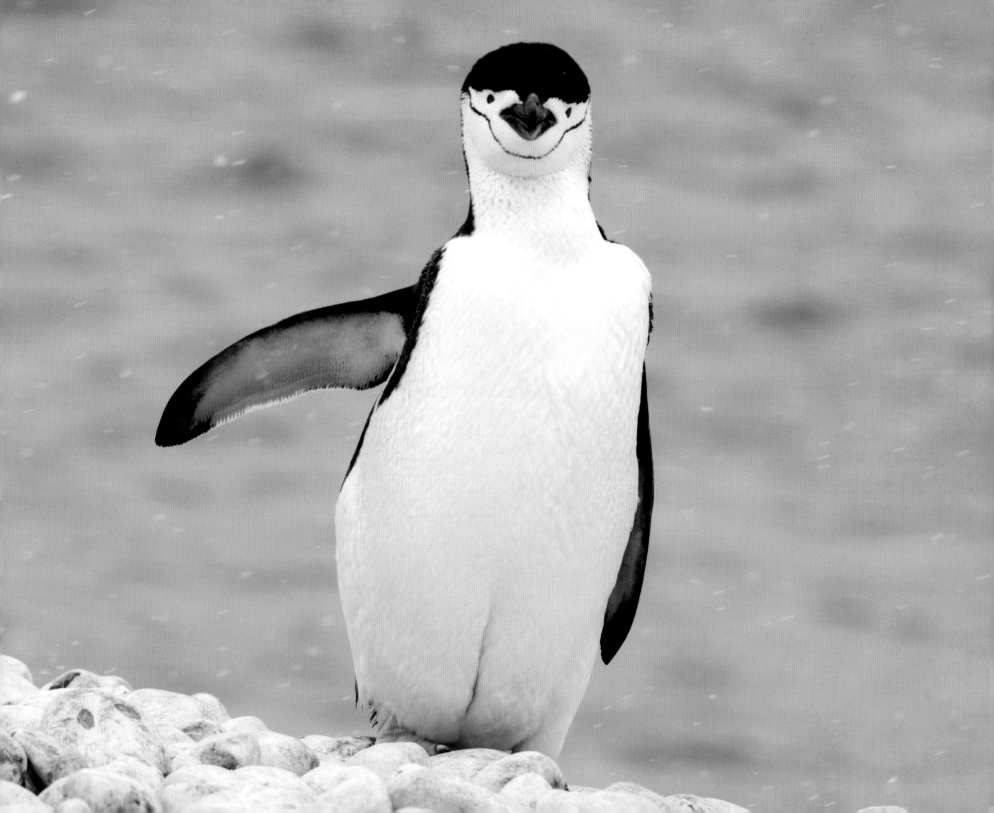

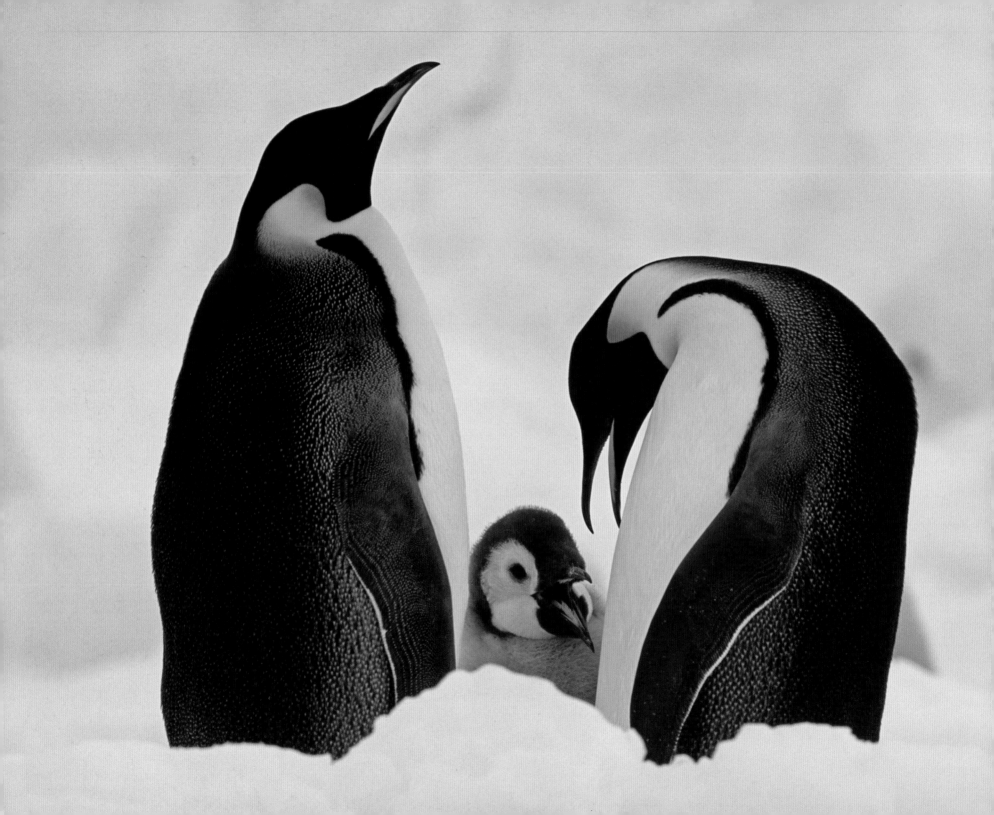

Yet it is the water that defines them. There, the penguin's streamlined body is designed to move with almost no resistance, like a feathered torpedo. My first sight of a swimming penguin, a Gentoo gliding through a shallow pool in Antarctica, was a revelation. That brief vision of aquatic grace dispelled forever any lingering notion of them as flightless birds. Penguins can fly, all right: they simply fly underwater. My reaction was hardly unique; that first sight of a flying penguin, in zoos or aquarium displays, invariably draws gasps of pleasure from children and adults alike. Their grace and ease in the water is simply so *unexpected*.

A rare domestic moment among an Emperor Penguin family: with an insatiably hungry chick, one parent or the other is typically at sea getting food. During the five months from hatching to fledging, these adults may see one another only during these brief exchanges at the nest.

Sticklers for detail will point out that unlike aerial fliers, penguins do not rely on the lift of their wings to keep them aloft. True, penguins are slightly buoyant, and never in danger of sinking. But a penguin's wings are in almost every way analogous to those of airplanes; in cross section they show almost the exact profile of broad leading edge and thin trailing edge. And the motion in those beating wings makes no secret of either their origin or purpose.

As in all birds, a penguin's wing—or its flipper, if you prefer—is its primary means of propulsion, the equivalent of its propeller. But unlike those of flying birds, a penguin's wing does not rely on large flight feathers to give it power. Instead, a penguin's feathers are tiny, irrelevant to flight, and the entire wing has been fused into a narrow, rigid paddle—a far better tool than a broad wing in the heavy medium of water. Studies in wind tunnels (fortunately, conducted with penguin models, not the real thing) show that penguins are ideally designed for underwater travel, with little wasted energy, and minimal drag.

In addition, penguins gain thrust from both the upstroke and the downstroke of their wings, which makes their unique brand of flying that much more efficient, and gives them extraordinary underwater control. Aquatic predators, as all penguins

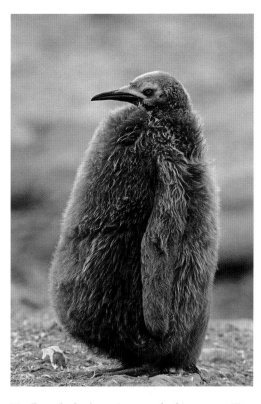

Hardly a hydrodynamic marvel, this young King Penguin looks more like a feathered laundry bag. After twelve months of feeding, King chicks may actually outweigh their parents by the time they fledge, a safety net until they are able to find their own food.

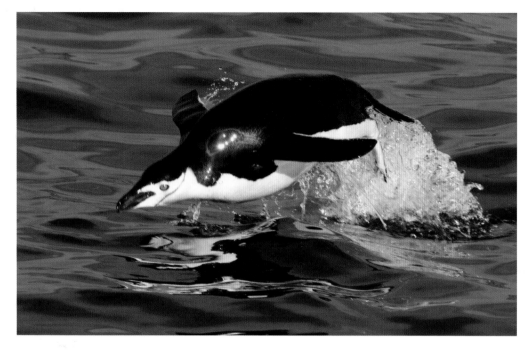

A Chinstrap Penguin becomes briefly airborne as it "porpoises" toward the shore. This is a much more efficient way of traveling quickly, reducing drag, and allowing the bird to catch a quick breath while in the air.

are, must be able to chase down and capture their prey underwater, which may require quick bursts of speed and the ability to make sharp, sudden turns.

But penguins are air-breathing birds, and so must also occasionally rise to the surface. When they are swimming slowly, this is no problem; they simply lift their heads out of the water, like ducks paddling around the pond. But when penguins really want to put on speed, they do something quite extraordinary: repeatedly bursting out of the water like Trident mis-

siles on low trajectory, snatching a breath in midair, and then plunging back below the surface. At times, the sea can explode with hundreds of penguins leaping out of the water at a time, like a barrage of stones skipping across the surface.

This spectacular display is called "porpoising," presumably because it was among those animals, dolphins and porpoises, that it was first observed. No one knows exactly what function it serves: not all penguin species do it, and among those that do, none do it more than in short bursts.

It may be that porpoising allows a bird to travel faster, since air provides less resistance than water, or perhaps it is primarily social—a kind of aquatic team sport. But it may also have more serious implications, serving as a way to confuse potential predators. The visual chaos created by dozens of leaping, splashing penguins can reduce a predator's ability to isolate an individual victim. Whatever the explanation, it is graceful and lovely to see, and just about as close as penguins get to being truly airborne.

Penguins are built for punishment, and for sea conditions that no other bird could withstand. This Rockhopper swims fearlessly through the raging surf on the Falkland Islands.

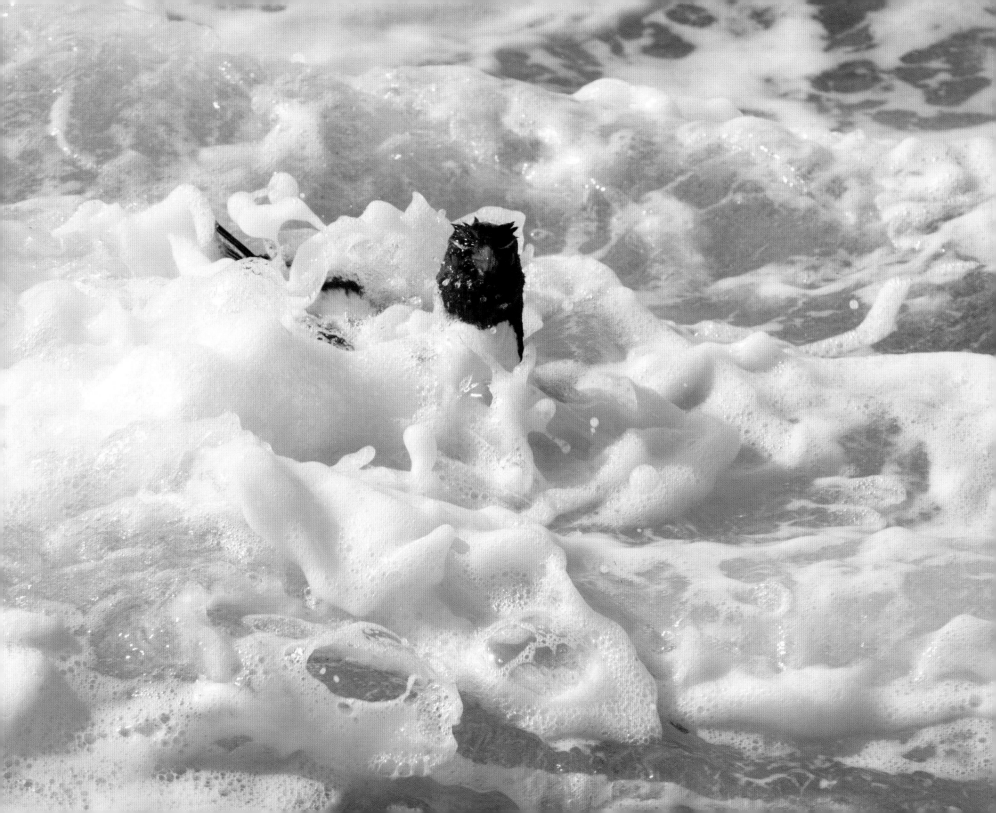

Gliding through clear water only inches deep, an African Penguin returns to the colony. If this isn't true flight, it is every bit as graceful.

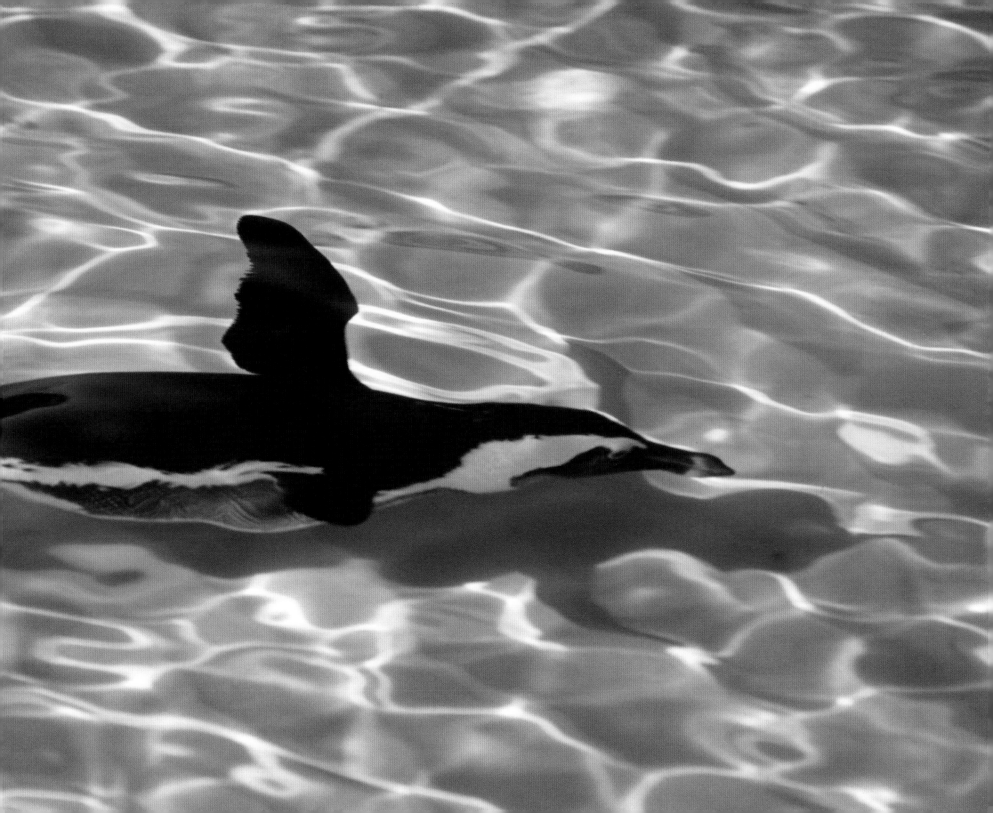

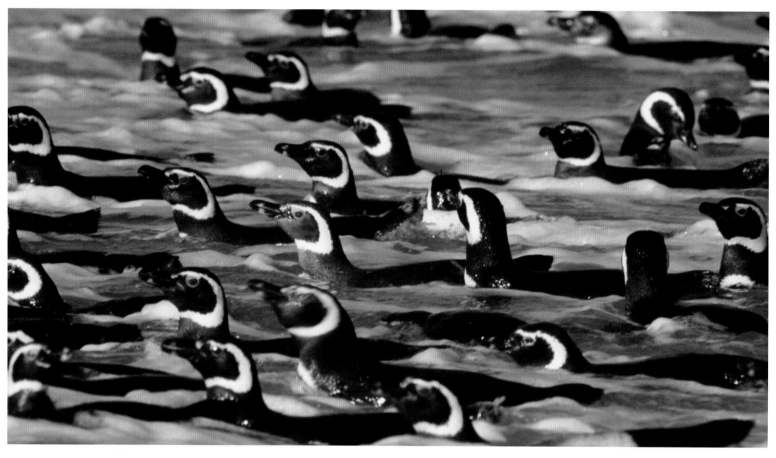

There is safety in numbers. This group of Magellanic Penguins forms a tight bunch in the water off the Falklands, where prowling sea lions are their chief predators.

Penguins look fast in the water, like torpedoes, yet observers have repeatedly overestimated their true speed. Penguins are only modestly fast swimmers; the fastest, the Emperor Penguin, can only attain speeds of about 9 miles (or 15 kilometers) per hour, the smaller penguins only half that. (None come close to aquatic speed-sters like the sailfish, which has been recorded at 68 mph, or 110 kph.)

But what they may lack in speed, penguins more than make up in diving ability. They are easily the deepest diving of all birds, and are surpassed among

A group of Adelies traverses a snowfield in the South Orkney Islands. I am always enchanted by visual patterns in the landscape, in this case made all the more compelling by the addition of a few penguins.

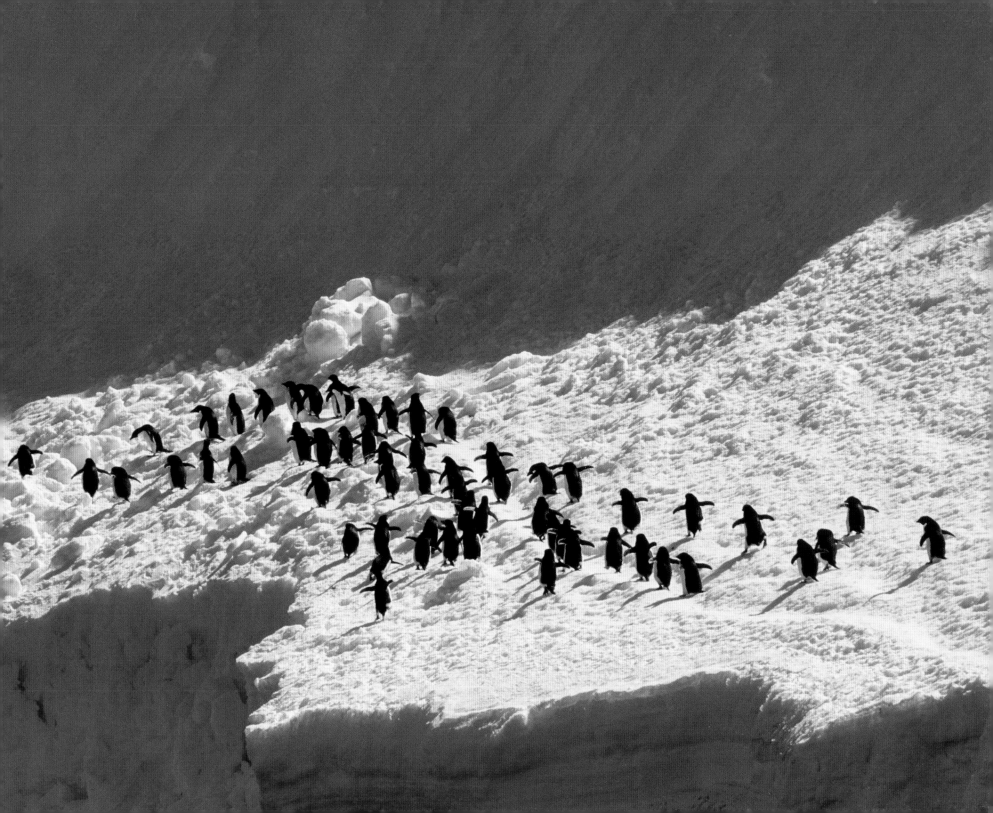

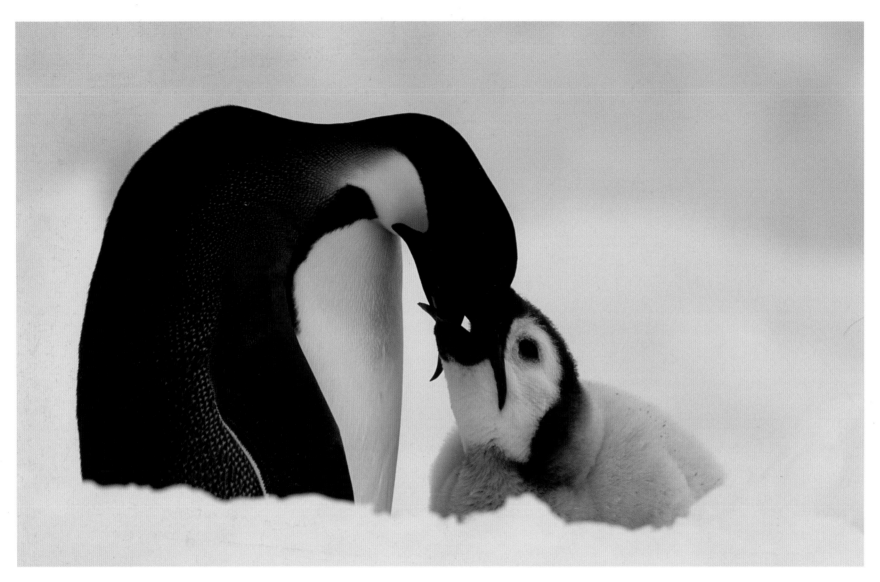

An Emperor Penguin feeds its chick by regurgitating
directly into the chick's mouth. Carrying undigested
food in its stomach, rather than in its bill, allows the
adult to swim more efficiently over long distances.

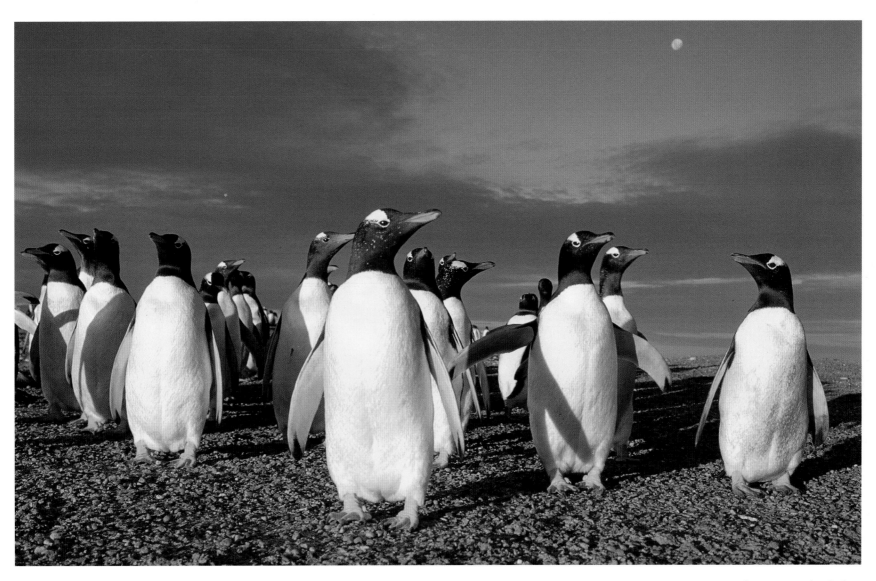

A penguin is a creature of spare parts: the feathers of a bird, the flippers of a seal—and the look of an upright fish. This curious group of Gentoos seems unsure what to make of me as I lay on the ground; they repeatedly ran away, then turned—and ran right back again for another look.

49

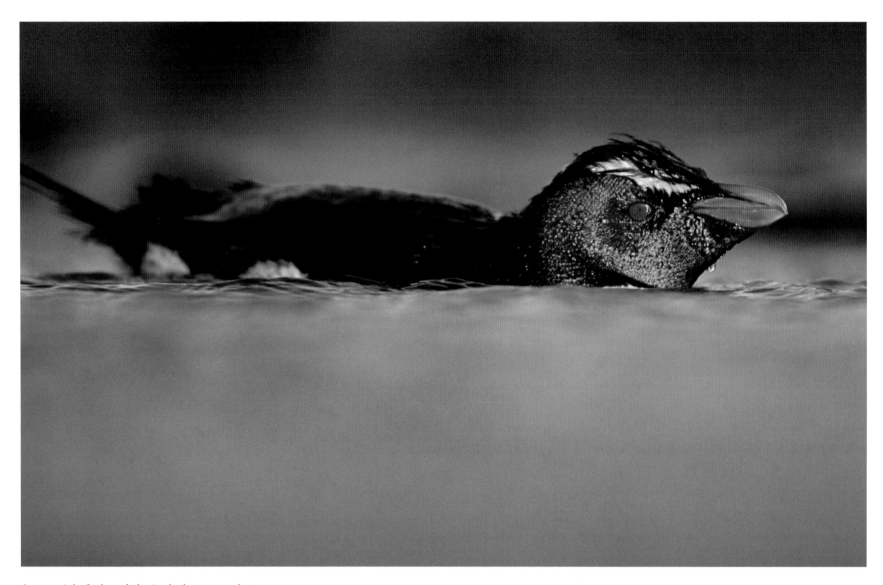

A penguin's feathers help it shed water and stay warm, so staying clean is essential. After a day spent in the squalor of the breeding colony, this Rockhopper enjoys a welcome bath in a small tide pool.

air-breathing animals only by whales and seals. Because penguins are only slightly buoyant, they can stay submerged as long as their oxygen and energy will allow. Emperor Penguins have been recorded at a depth of nearly 1,500 feet (450 meters), in search of squid and fish. The water pressure at this depth is enough to compress a penguin's lungs to 1/40th (or 2.5 percent) of their normal size, yet somehow Emperors are able to store enough oxygen in their blood and tissues to make dives of up to 18 minutes long.

Emperors specialize in deep water prey, sometimes feeding near the ocean bottom in the nearly total absence of light. Typically, however, penguins rely on seeing their prey, and feed during the daytime. In fact, research has shown that penguins tend to feed deeper as the sun gets higher and light penetrates farther under the surface. Squid and small fish are also thought to move toward deeper water during the day, and penguins are all too happy to follow them.

Besides being champion divers, penguins are also master travelers—especially for birds that were for so long dismissed

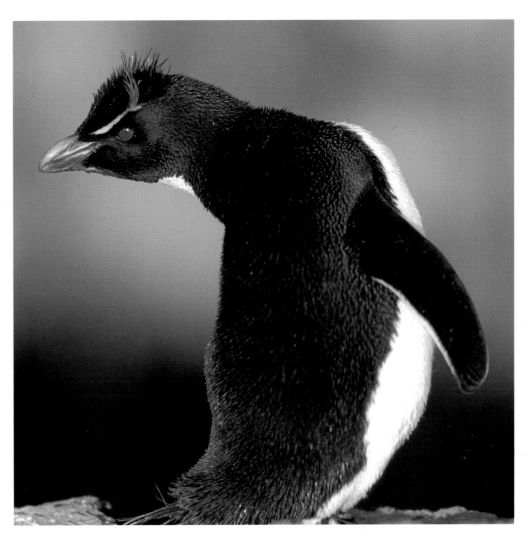

as "flightless." They seem to think nothing of traveling hundreds of miles on feeding trips, and during the long months of winter, when they are no longer tied to their

Penguins are surprisingly flexible, like this Rockhopper Penguin in the Falklands; his head turned all the way around for a better look. Those crimson-colored eyes give Rockhoppers an almost fierce stare.

51

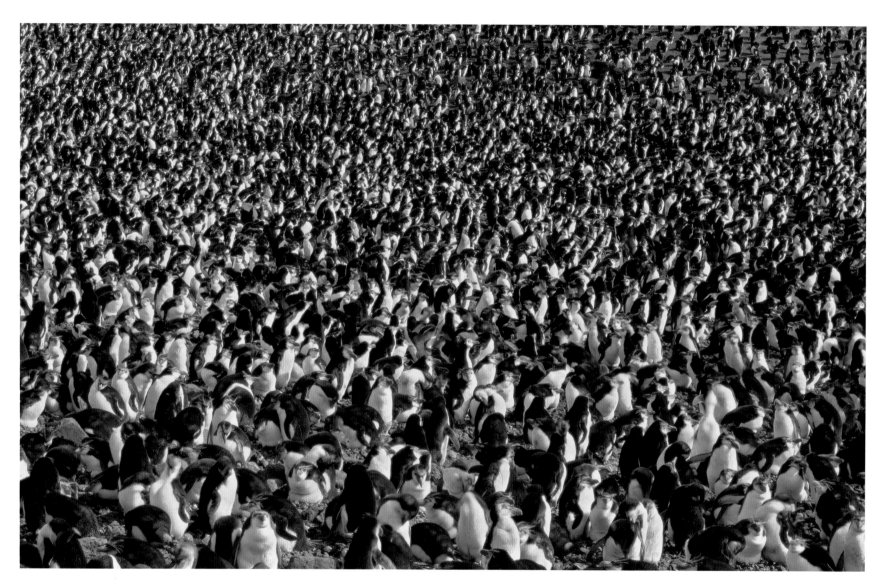

On Macquarie Island, this colony of Royal Penguins was in a constant thrum of activity, with birds coming, going, courting, and fighting. The only thing missing here is the deafening sound—and the overpowering smell.

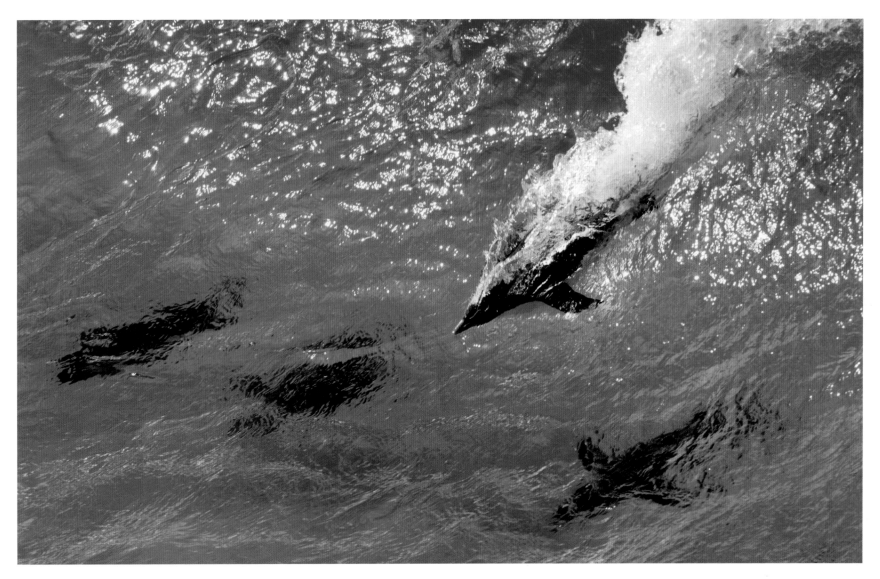

Returning to shore during a summer storm, these Rockhoppers seemed to delight in surfing in to the beach. If I didn't know better, I'd swear they swam back out and did it again.

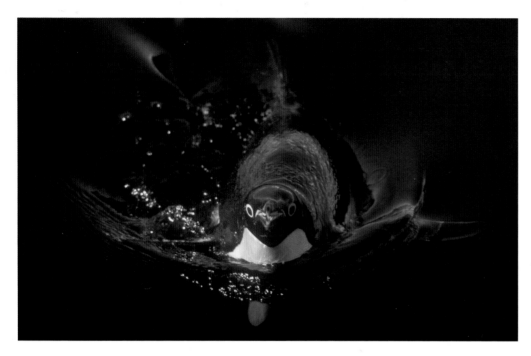

An Adelie Penguin pops up to the surface after a feeding dive along the edge of the pack ice. Although Adelies have been recorded diving over 500 feet, they typically feed within a hundred feet of the surface.

sits on them first, and what kind of food they bring back for their chicks. Yet at sea, where penguins spend most of their lives, it is hard to say anything very insightful about what they do. They travel, they eat— they may even sleep. That's about it.

..

Imagine if Martians landed on Earth in the middle of the night and began secretly watching us in our beds, hoping to gain some insight into our behavior as a species. True, they might record some rather interesting things, but no one would suggest that this was a representative sample of how we spend our time. Watching penguins on shore presents a similarly skewed perspective: it may be fascinating stuff, but it's only a small part of the story.

..

colonies, they may range over thousands of square miles of the southern ocean. The only trouble is that, in many cases, we have no idea where they go.

One of the persistent barriers to our understanding of penguins is that we tend to see them only on land. Yet a penguin's time ashore is in many ways an anomaly, a holdover from its past—a necessary chore that follows the persistent urge to breed. Researchers have gathered enormous amounts of data about how long it takes for eggs to hatch, which parent

Away from the colony, though, we don't have much to go on. Happily, this is beginning to change, especially with the help of

This cluster of Chinstraps and Adelies milled around this ice edge for half an hour before the first brave penguin took the plunge. Then, in a rush, the rest followed behind, hoping to "swamp" lurking predators and reduce the risk for each individual.

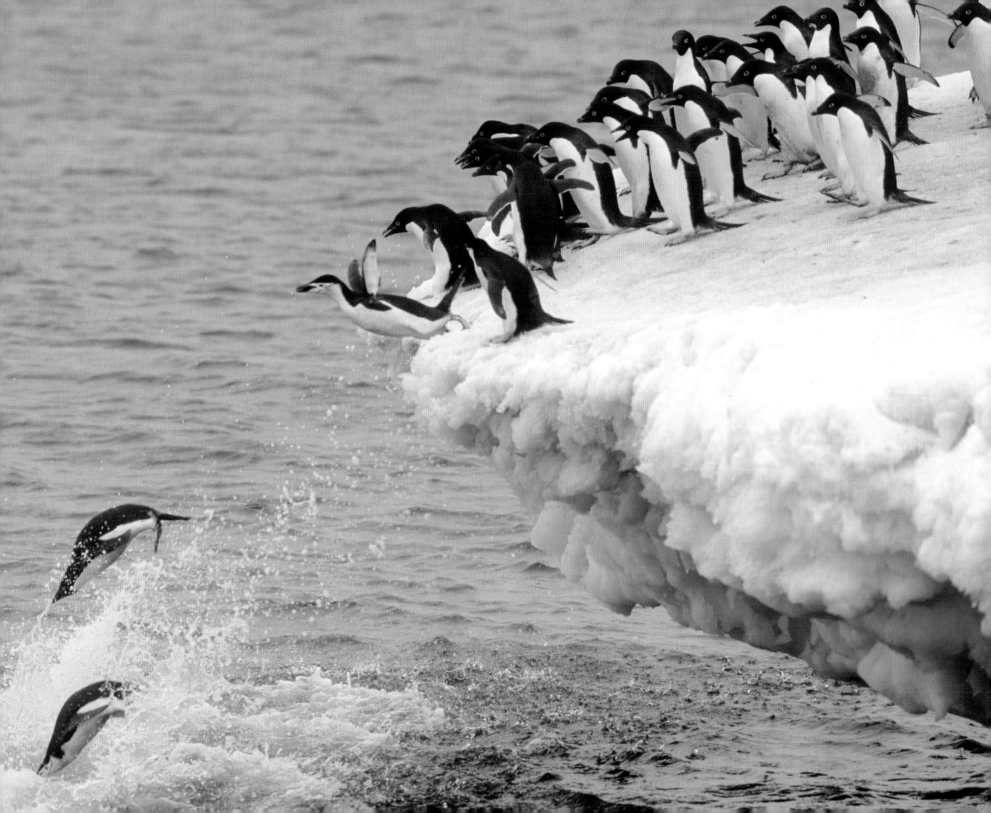

Coming ashore always presents a few awkward moments for a penguin like this Royal Penguin on Macquarie Island. Somehow the bird must get from horizontal to vertical, with neither hands nor knees.

several new electronic devices for tracking the movements of animals. Two of these are time-depth recorders and satellite transponders, the first designed to reveal how long and how deep penguins dive, the latter to provide an accurate map of their movements. Glued to a penguin's back, these little gizmos are telling us virtually everything we know about penguins during their time at sea.

Not surprisingly, this has become one of the most active areas of penguin research, and is revealing tantalizing facts about what they do after they leave their colonies. The Emperor's deep dives would have seemed unimaginable had they not been carrying recorders on their backs. And who could have suspected that a King Penguin would regularly travel over 1,000 miles (1,600 kilometers) in search of food? We can, for the first time, get hour-by-hour reports from penguins on the move, whether they are feeding, swimming, or just standing around on an iceberg.

Yet there are still many things these instruments can't tell us. How, for instance, do penguins know where they are going? How do they find their food and then turn around to head home—often swimming in a direct line for their waiting, hungry chicks? We know they do this; we can see their satellite tracks marking an unhesitating beeline back to the colony. But how do they manage it? Do they read the stars? Do they taste the currents? Do they ask directions? We have no idea.

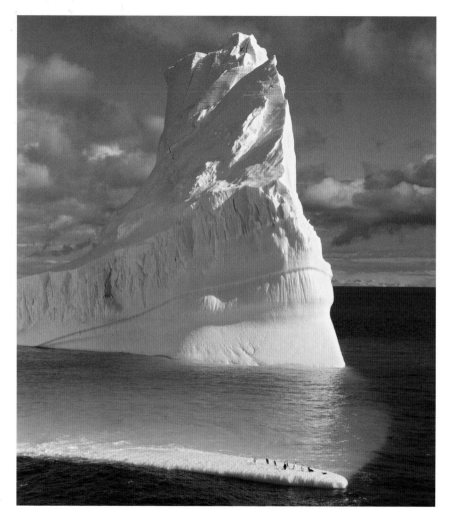

Passing icebergs are irresistible resting places for penguins, and important social crossroads—places to catch up on news of a passing krill swarm, perhaps. I was drawn to the majestic lines of this iceberg from miles away—and only much later spotted the penguins, lounging about on one tiny corner.

Gentoos gather at the water's edge, each waiting for someone else to make the first move into the water. A large sea lion patrols this beach every day: at least one or two penguins will not make it home again.

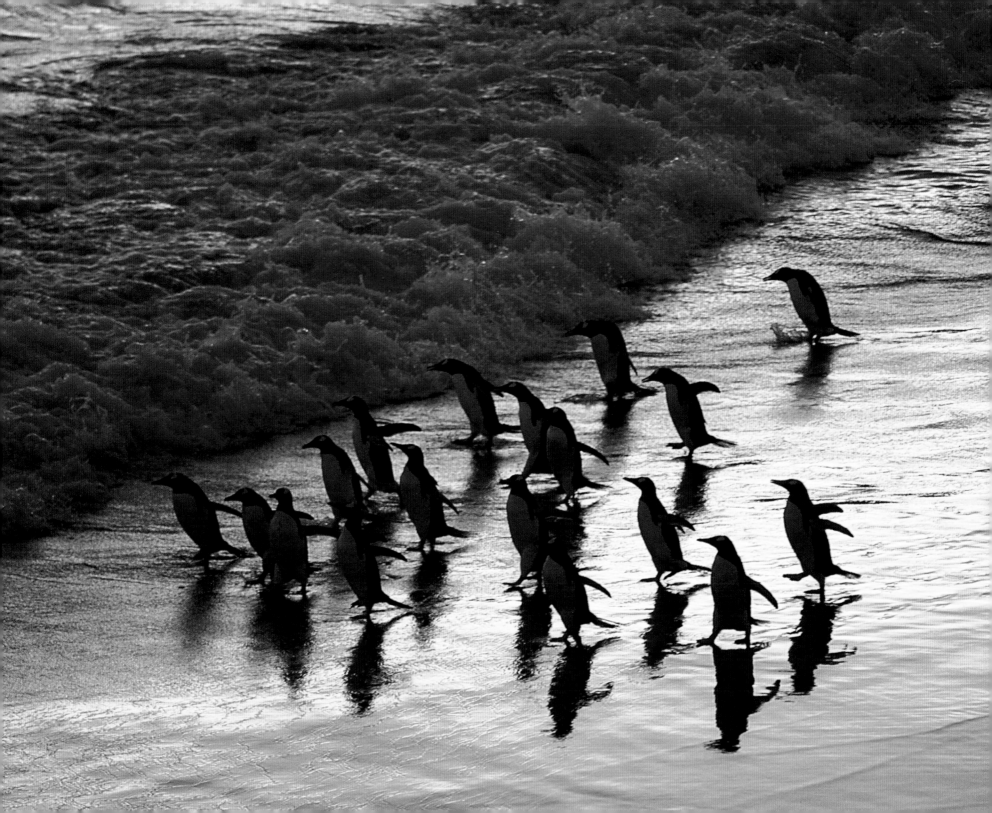

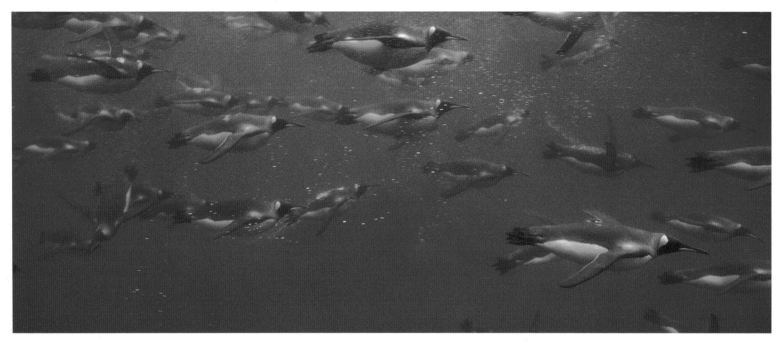

Penguins underwater, like these Kings, are sleek and powerful. With no need for lightness, they have sacrificed the hollow bones of flying birds. This helps them remain almost neutrally buoyant in water, and allows them to dive deeply in search of prey.

Sadly, even the best technology has its limits. These electronic devices are expensive little toys, and few researchers can afford to place them onto the backs of hundreds of penguins. As a result, the amount of information we can gather is still patchy and often dependent on scarce funding. More times than not, the only way researchers know a bird has survived the winter is by checking to see if it comes back the following year. Most do, but every year, many do not.

Penguins face a variety of natural dangers at sea, not the least of which are leopard seals and sea lions. In Antarctic waters, leopard seals are particularly relentless hunters, stalking the edge of penguin colonies in search of careless or isolated birds. Nor are attacks a rarity; in one Adelie penguin colony, leopard seals were estimated to have killed as many as 5 percent of the adults birds in a single year. This persistent threat

Tiny penguins in a vast landscape: Antarctic penguins inhabit a world of oversized scale. The mountains are grand, the icebergs towering, and the weather extreme. Yet most species live in temperate latitudes, amid landscapes much less dramatic.

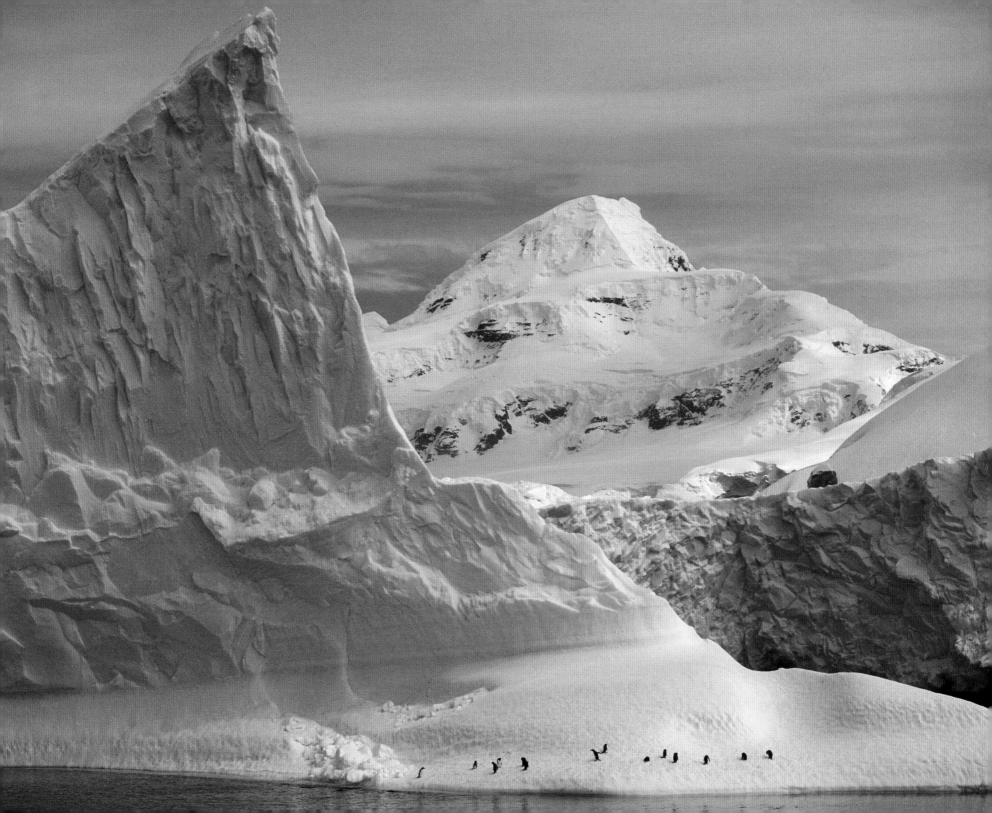

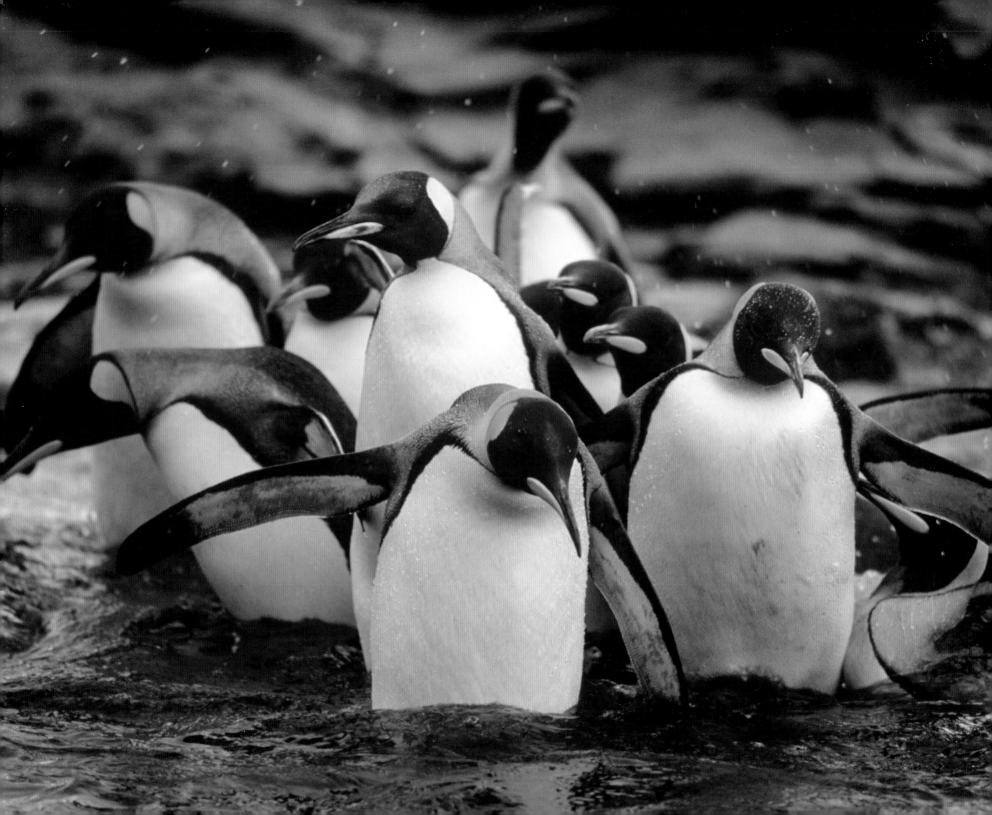

encourages one of the most unexpected traits of penguins—their fear of the water.

You would not expect a bird so much at home in the sea to be so glad to get out of it. Yet this is very often the case. Penguins have little to fear on land; for them, danger lurks in the sea. For that reason, penguins often cling to a rock or ice floe, jammed together with their peers, looking down at the water as if it were death itself.

It may be just that. No penguin wants to be the first to enter the water in case a leopard seal is waiting just below the surface. Instead, they go to great lengths to delay the inevitable, hoping that some other poor fool will make the first move. Then, as often happens, one penguin finally screws up the courage to go, to which the rest respond by madly scrambling over each other in an effort to join in. I have literally seen the water boil like this, filled with frantic penguins, all trying to get to the refuge of open water. Like schooling fish, penguins assume that there is safety in numbers, that their chances are better against a hungry seal if they are not alone.

King Penguins have nothing to fear on land. For them, danger lurks in the sea where leopard seals or orcas could be waiting for them. No surprise, then, that penguins enter the water with reluctance, and exit with enthusiasm—and relief.

Leopard seals are not the only predators a penguin faces at sea. On the island of South Georgia, it is believed that as many as ten thousand adult penguins are killed and eaten every year by Antarctic fur seals. And in the Falkland Islands, pods of killer whales have been seen hunting penguins, herding them into tight groups in shallow water and then picking them off, one by one. Once ashore, however, a penguin's anxiety is immediately transformed. With no predators on land, penguins can relax, and when they first come out of the water, most do just that. Many stand around the beach, having a good scratch and cleaning up a bit before continuing on to the colony. Perhaps they know what squalor lies ahead of them.

Leopard seals and fur seals are the primary predators for adult penguins, like this King who has survived such a recent attack—at least for now. Penguins seem capable of surviving even the most catastrophic wound.

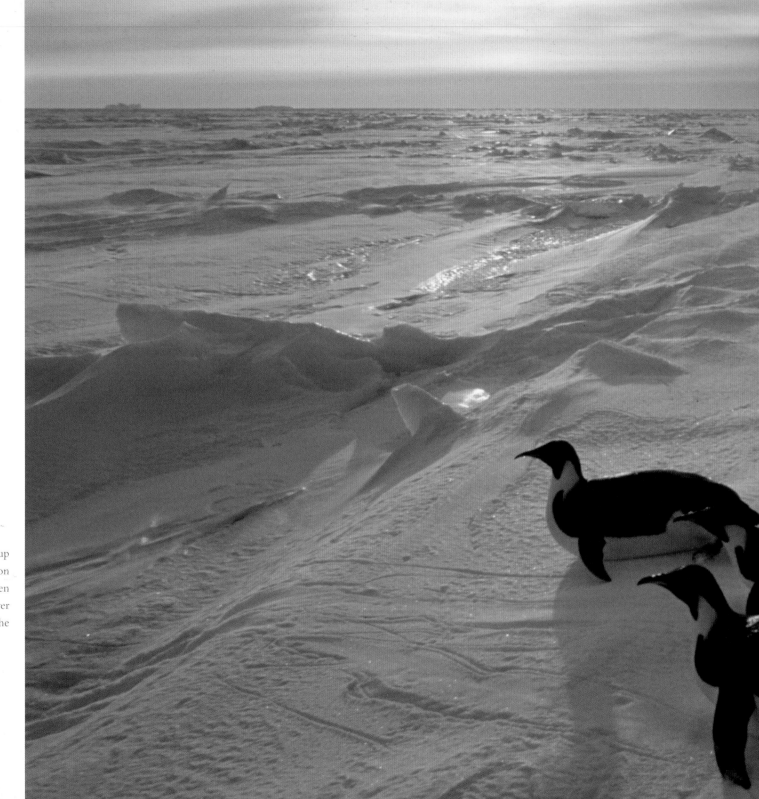

Beneath the midnight sun, a group of Emperors slide along the ice on their bellies. For them it is often the most efficient way to cover what may be many miles over the ice to the colony.

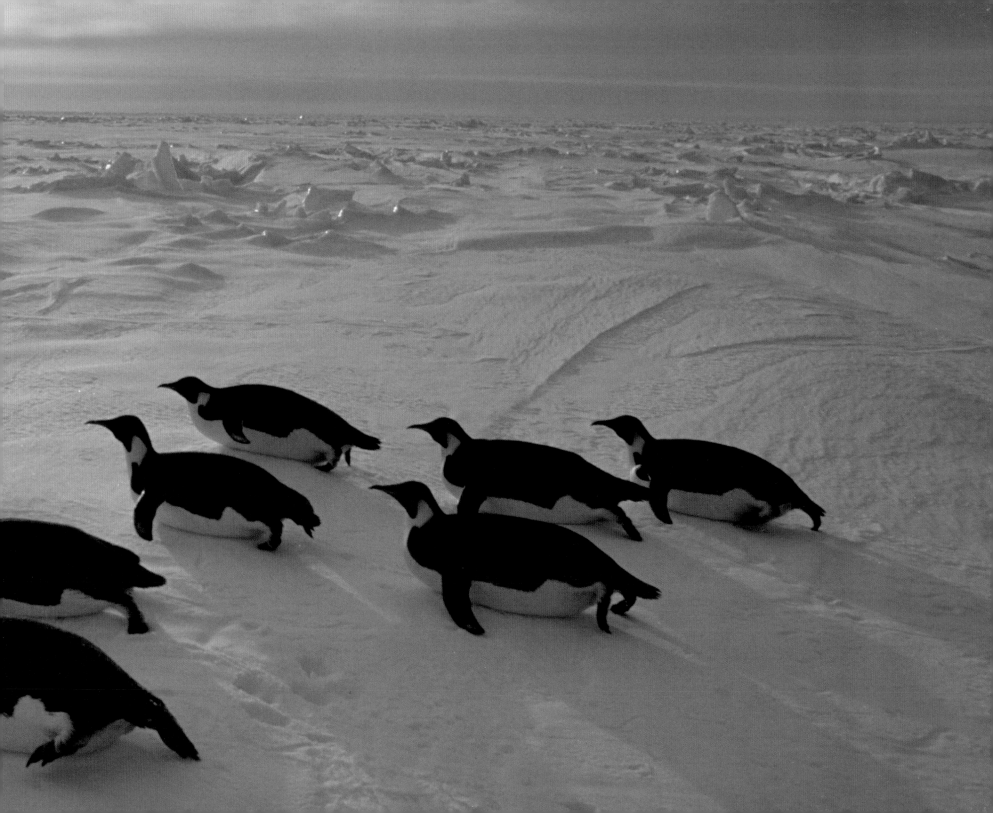

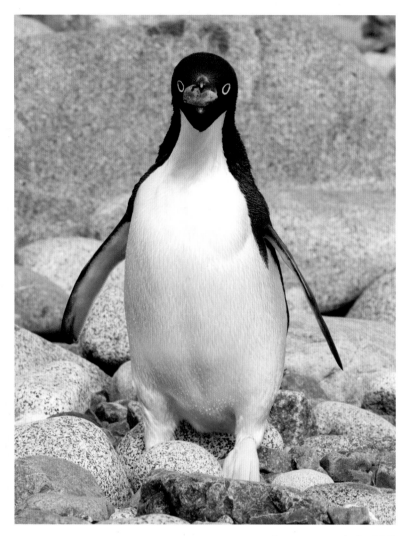

Pebbles help Adelie Penguins keep their eggs high and dry, especially during the spring snowmelt. They will spend vast amounts of time collecting and rearranging their nest pebbles and, when necessary, stealing them from their neighbors.

Staying in a group also reduces the chances of having your eggs or chicks snatched by nest robbers like gulls and skuas; the risk is spread thinner among many neighbors. And because small, isolated colonies are often harder hit, there is considerable incentive to remain within a large, established colony rather than going off to start a new one. For that reason, big colonies tend to get bigger until they fill every available inch of available ground. In addition, because the most vulnerable nests are usually those on the exposed fringes of breeding colonies, these are often left to younger, less experienced penguins. Older, smarter birds—penguins with seniority—claim sites closer to the middle.

Not all penguins, however, share this pleasure in one another's company. The Yellow-eyed Penguin, found only at the southern tip of New Zealand and its offshore islands, takes a decidedly different approach to its social life. The Yellow-eyed, known to the Maoris as "hoiho" (a word that translates as "noise shouter"), makes its nest inside dense coastal forests, in dark hollows or natural holes, far from other birds.

It is an unexpected sight, watching a Yellow-eyed tiptoe silently through a mossy forest, the only sounds those of the wind and the eerie songs of bellbirds and parakeets. The whole scene is very un-penguin-like. No wonder many people have accused the Yellow-eyed Penguin of being somehow more primitive than other species—as if fondness for guano and noise was a highly evolved trait.

Perhaps no creatures on earth—except humans—form such large, dense gatherings as do King Penguins, here on the plains of Fortuna Bay, South Georgia Island.

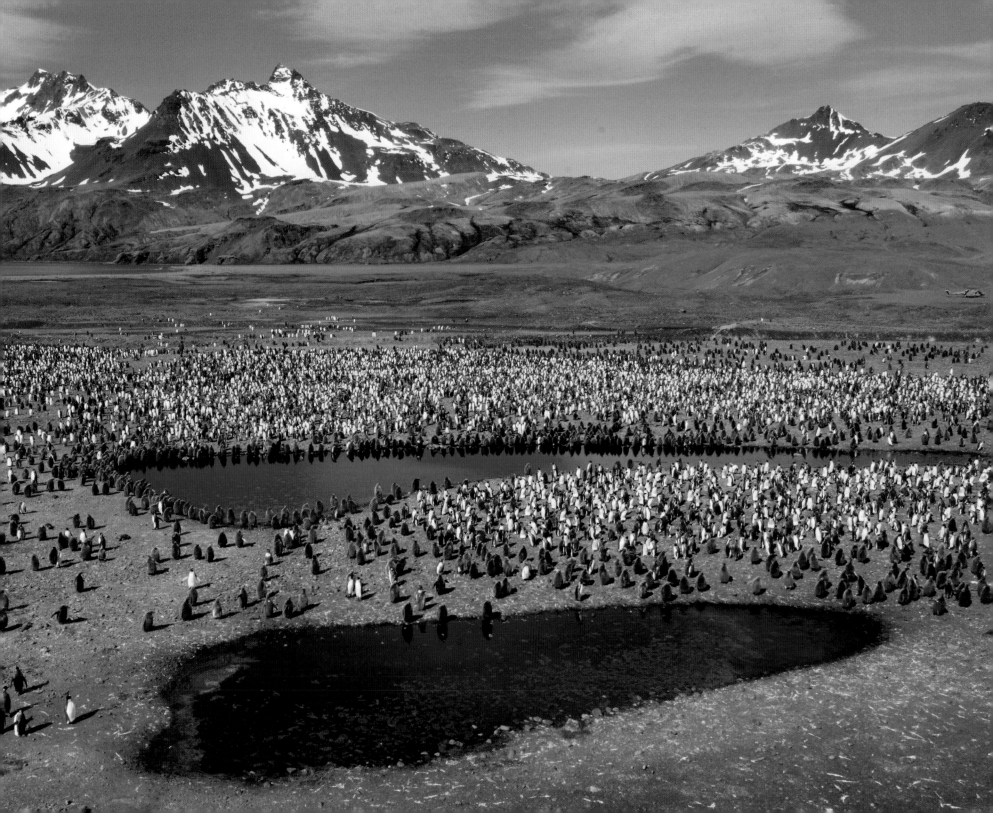

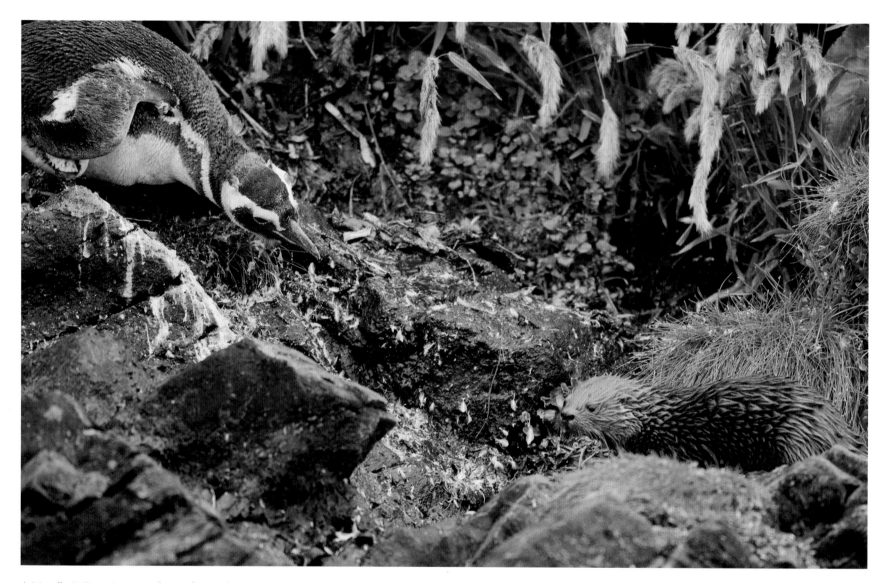

A Magellanic Penguin comes face to face with an en-
dangered marine otter in southern Chile. Both live
in burrows along the rugged coast of Chiloe Island
and feed in the rich waters of the Humboldt Current.

Just a small portion of the huge "Big Mac" colony of Macaroni Penguins on Bird Island, off the coast of South Georgia. The vast numbers of penguins in colonies like this reflect the biological abundance of the Southern Ocean.

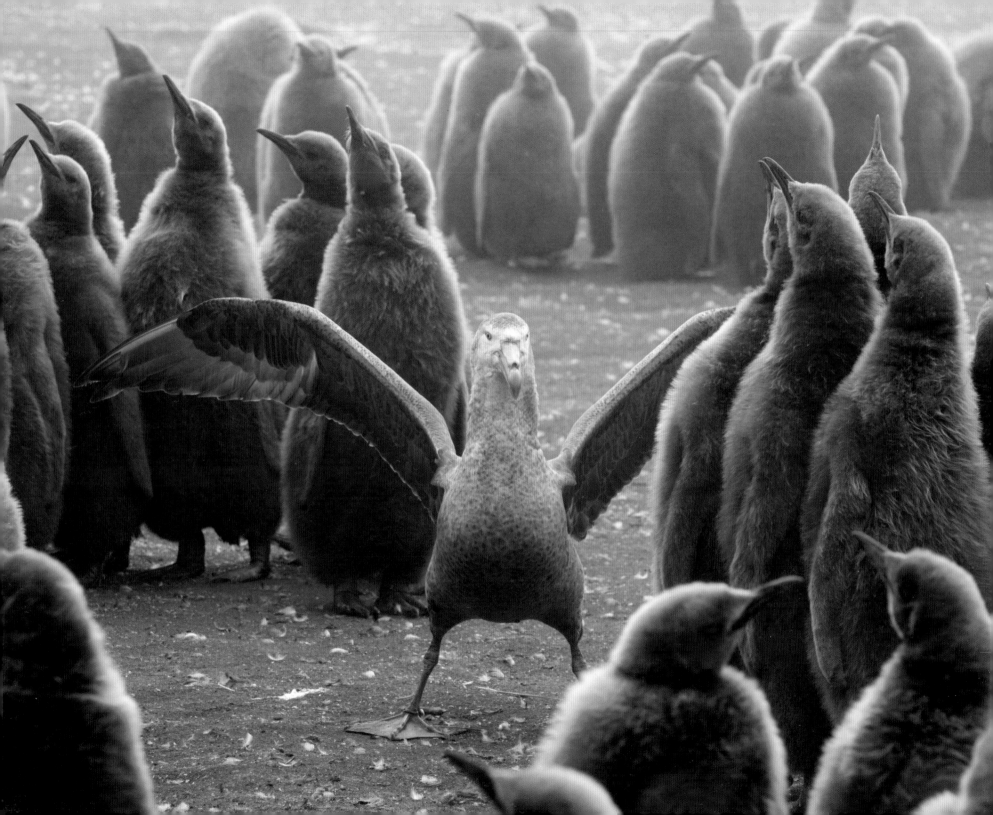

No matter what the species, meanwhile, a penguin's nest is a simple affair, reflecting the paucity of suitable building materials often available. Most are content with little more than a rough scrape on the ground, adorned with a few rocks or, if available, a feeble construction of twigs or blades of grass. These skimpy nests offer little protection for the egg, but are sacred, and fiercely defended, nonetheless.

For some penguins, especially social birds like the Gentoo and the Adelie, nest-building can elicit some decidedly antisocial behavior. Both use pebbles in their nest to build sketchy rings around their chosen sites. (Although a nest of rocks would seem an uncomfortable perch, they do help keep the eggs up and away from standing water or melting snow.) But pebbles are often at a premium in some locations, and competition for them can be fierce.

For that reason, some penguins simply steal them from the nests of their

neighbors, even right out from underneath them. Maintaining your nest, therefore, requires constant vigilance; turn your back, and you may find your pebbles gone. In one clever—and revealing—study, a researcher marked all the pebbles in one penguin's nest and the next day found that almost all had "migrated" into the nests of its neighbors.

A giant petrel races into a cluster of King Penguin chicks, looking for weak or injured birds. Although primarily scavengers, these petrels are quick to take advantage of an opportunity for a fresh meal.

A pair of Falkland skuas tears apart a very young Gentoo chick they have managed to snatch from an inattentive parent. They, in turn, will carry that meat home to their own hungry chicks.

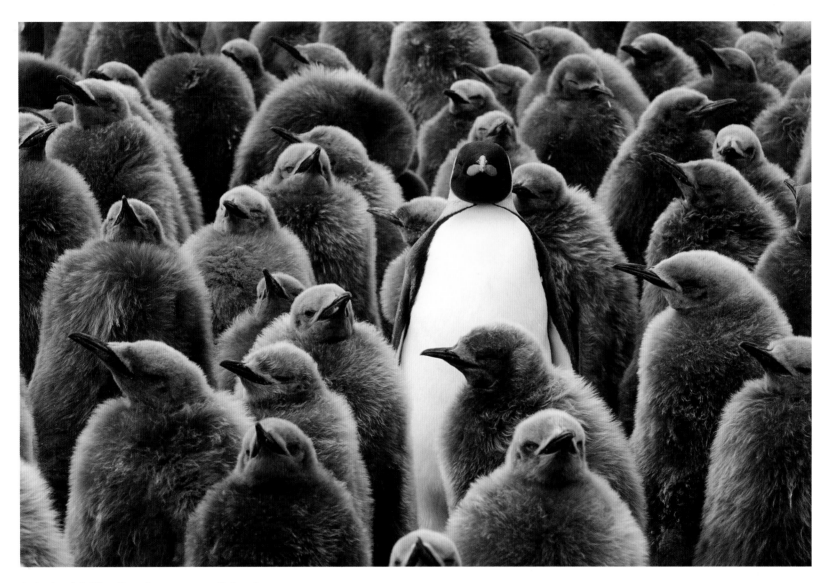

A single adult King Penguin seems out of place in
the middle of a crèche of fluffy juveniles. Confronted
with hundreds of lookalikes, a returning adult can
recognize the unique sound of its own chick's voice.

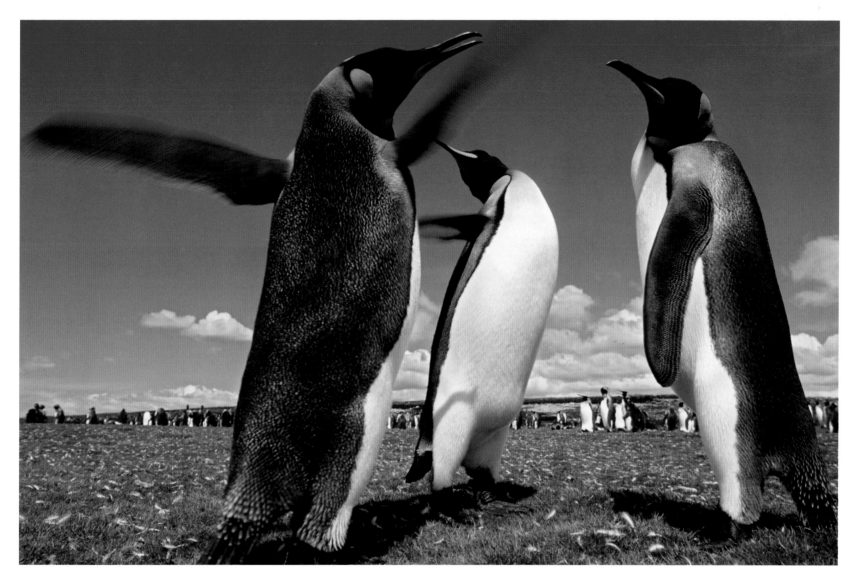

One can only guess what offense sparked this battle between three King Penguins in the Falklands. Whatever the argument, penguins use the weapons available, in this case hammering away at one another with the equivalent of fists—their board-hard flippers.

Sometimes this lust for pebbles can elicit even more unexpected behavior. A recent study revealed that female Adelies may actually resort to "prostitution" to get the pebbles they need. In return for pebble gifts, such a female allows males other than her partner to mate with her.

Other penguins, meanwhile, prefer to build underground burrows to hide their nests. Not surprisingly, these tend to be largely mainland species, such as the African Penguin and Little Penguin, which must contend with land-based predators. For other species, burrows may play a dual role. The Magellanic Penguin, which nests on the desert shores of Patagonia, relies on its burrow for protection from predators, but also to protect its eggs from overheating in the intense sun.

Two penguin species, the King and Emperor, simply prefer to carry their nests with them. Rather than constructing a nest of any kind, these birds incubate their eggs and brood their chicks *on top of their feet*. In the case of the Emperor, this is crucial, since these birds breed directly on the surface of the polar ice—a cold, inhospitable place for a young chick.

..

No matter what their nesting style, penguins benefit from the proximity of others. In fact, research seems to suggest that a certain minimum group size may actually be necessary before social birds—like penguins—will even *begin* to breed. It is as if they need the clamor and the chaos to get into the mood.

..

There are a number of things that can encourage breeding in penguins. These include not just their courtship and greeting rituals—things you would expect would put them in an amorous mood—but also all the territorial squabbles and bad behavior that are so much a part of colonial life. Research has shown that fighting is an essential component in the onset of breeding.

When a Rockhopper returns from the sea and joins its mate at the nest, they greet one another with a ritualized head-bobbing and a series of loud, braying calls. It may look like a fight, but it's more likely a happy event.

A predatory skua nests on an airy perch surrounded by a Macaroni Penguin colony on South Georgia, his own personal fast-food restaurant.

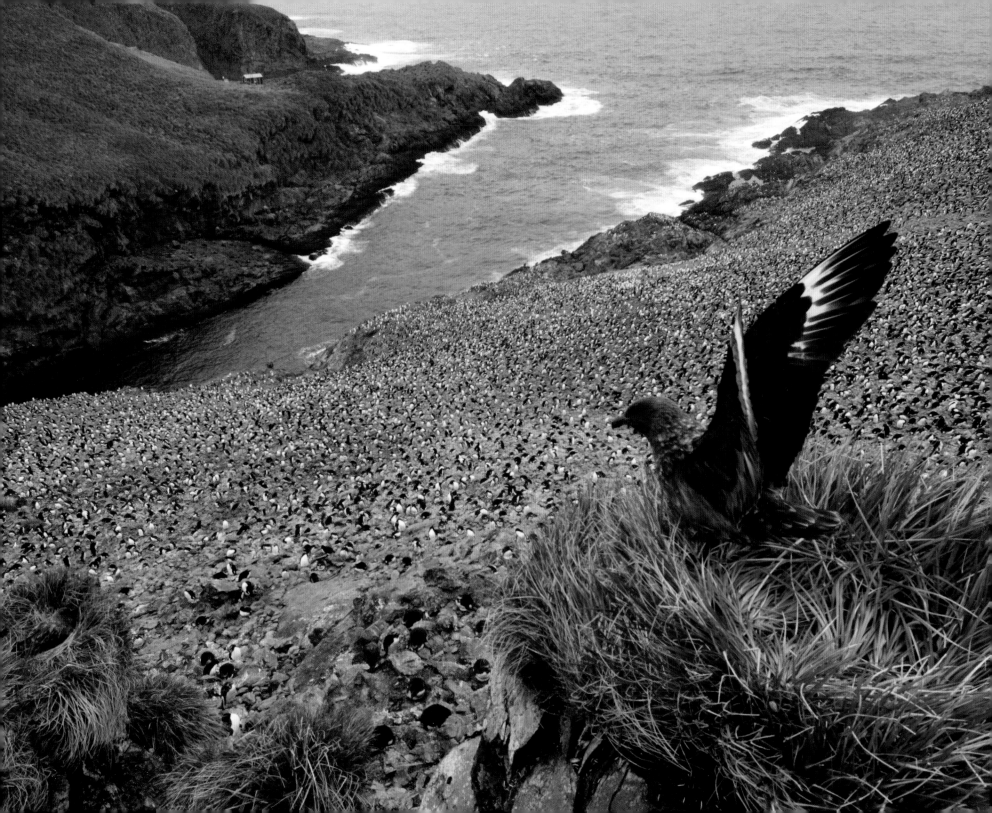

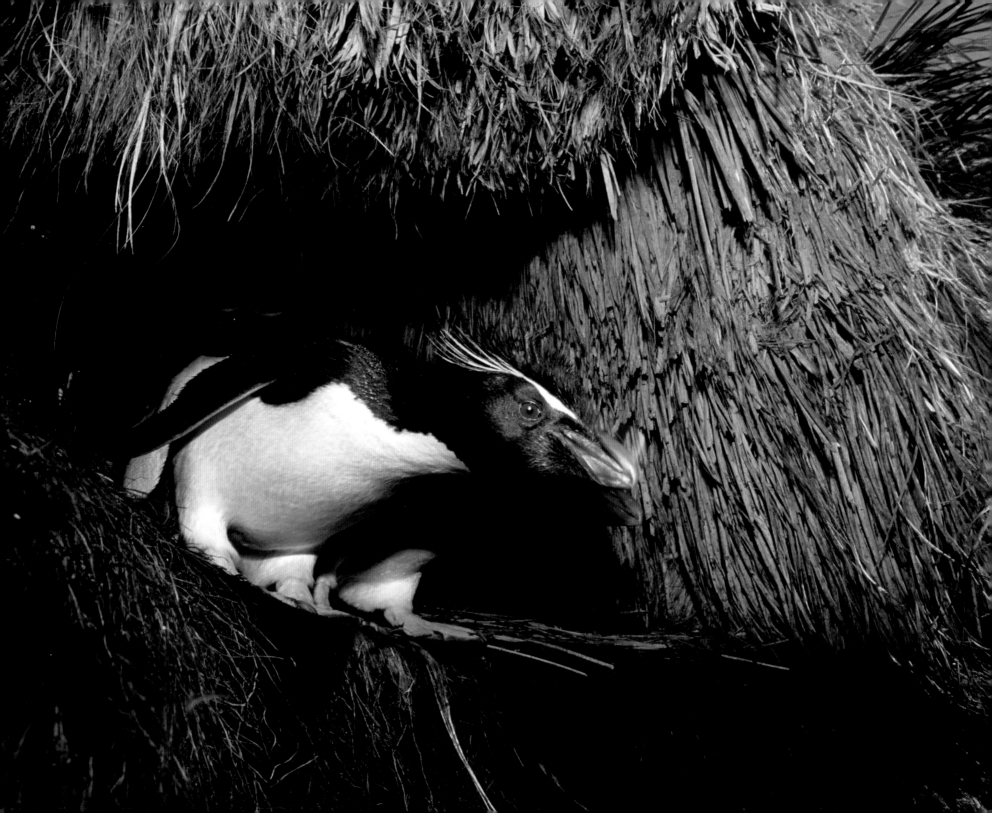

One of the ineffable charms of sitting alongside a bustling penguin colony is watching the endless little dramas that fill their thousands of busy lives. At any one time, you can be guaranteed a full program of fighting, stealing, love and affection, fear and loathing—and with all the attendant sound effects. Hardly a moment goes by without some sort of argument. This is one of the ironies of living *en masse*: colonial penguins seem to only reluctantly accept the fact that they are surrounded by other birds. Most of the time, they act as if they'd prefer them all to simply go away.

Penguins are enthusiastic fighters, and although they have only two real weapons at their disposal, their bills and their flippers, both can be formidable. King Penguins, for instance, use their long hard flippers in great slapping contests, usually to see who will have the right to mate with whom. These flipper bouts are serious affairs; the muscles that guide a penguin's flipper are powerful, and can inflict a bone-breaking wallop.

Gentoo Penguins warn stray penguins away from their territories by angrily jabbing at them with their sharp beaks—often without even bothering to get up from their nests. As a result, even the densest breeding colonies display a distinct space between nests, a gap that corresponds almost exactly with the pecking radius of the species: the bigger the bird, the larger the distance between them.

But life in a penguin colony is not all argument and conflict; it is also a place of love and longing. It is certainly a place of ritual. To a large measure, a penguin's social life is governed by elaborate dances and displays. Bowing, bill-pointing, raucous calling, and ecstatic quivering are all part of a penguin's repertoire, whether it is in angry confrontation, or the rapture of courtship. Sometimes it's hard to tell the difference.

Each penguin species has its own unique suite of breeding behaviors, which may help avoid interbreeding with other sorts of penguins. Courting Emperors, for

A Rockhopper in the Falklands works his way through narrow channels in the tussock grass to find his nest. This long, lush tussock grass is typical of cool, maritime sub-Antarctic islands where most penguin species live.

A young Adelie Penguin in that awkward, somewhat ridiculous stage between chick and adult, exchanging its natal down for grown-up plumage. For now, it has nothing much to do but exercise its flippers and wait for the molt to be over.

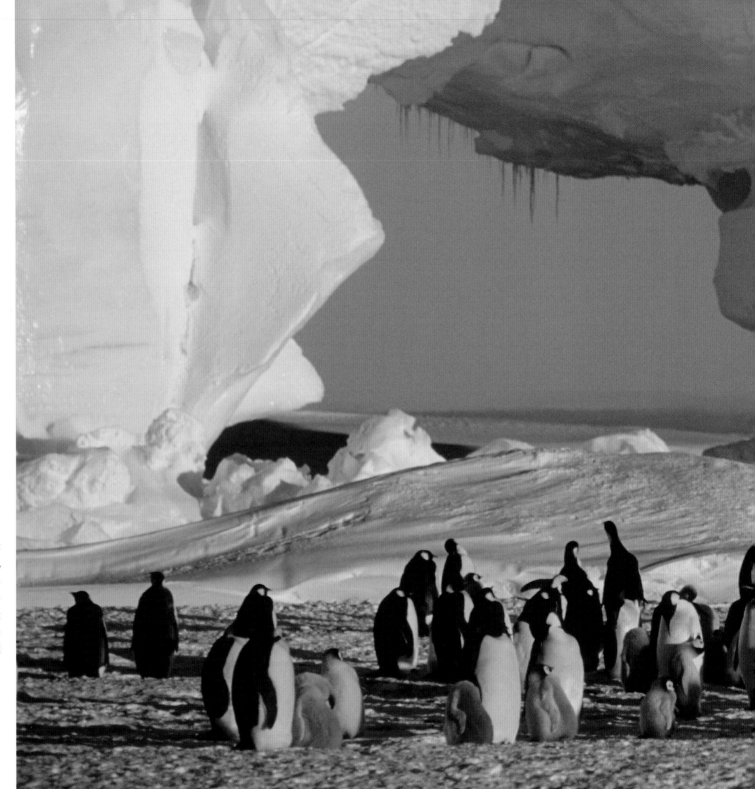

Normally, Emperors will not set foot on land in their entire lives, choosing instead to breed on "fast" ice, sea ice that remains attached to shore. Here they must raise their young to independence before the ice melts or is carried away by tide and wind.

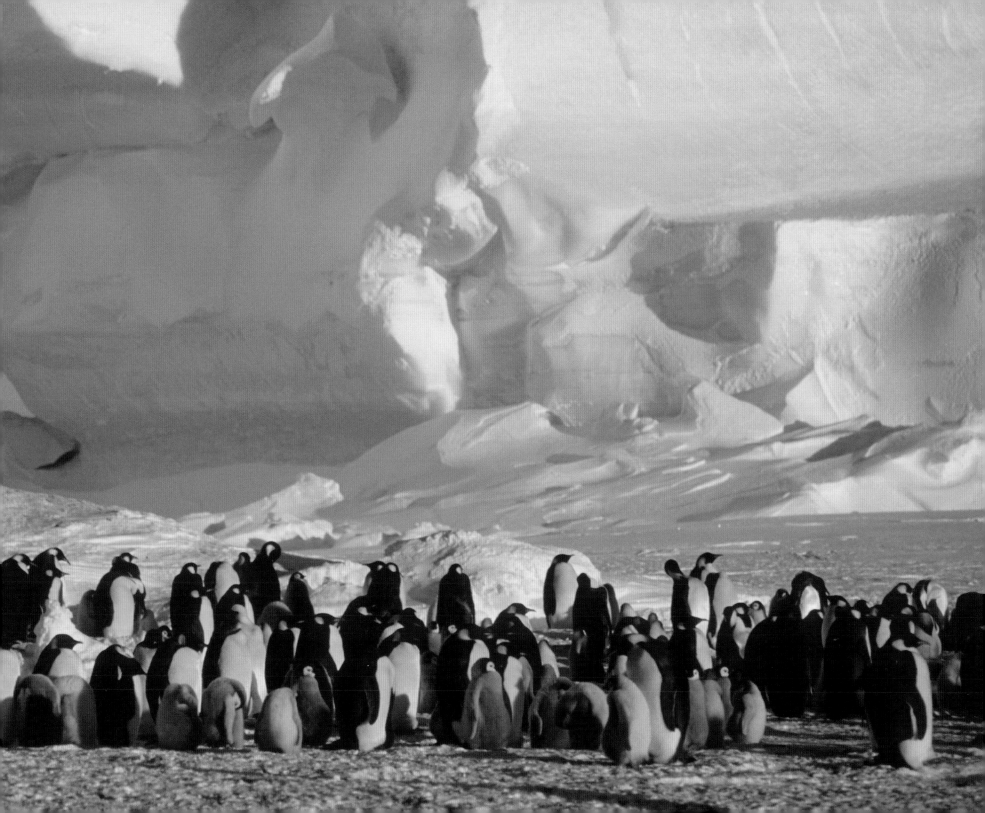

A pair of courting Fiordland Penguins makes a nest in a hollowed out log. Although there remain large areas of good nesting habitat for these birds on New Zealand's wild South Island, exotic predators eat more than half of the penguin chicks hatched every year.

These bizarre, often comical, performances make anthropomorphism almost inevitable. We can't help but see ourselves in these romantic dances and marital cooing. Among the most irresistible displays are those of the King Penguin. These elegant birds perform a prenuptial march in which the female follows her mate, step for step, through the colony, their bodies swaying and their heads rocking back and forth in unison. You can almost hear the silly music that accompanies so many nature films on penguins.

Although each penguin species has its own unique repertoire of display, when the time comes to mate, all penguins turn to the same playbook. In part, this is a result of the rather complicated logistics of mating. In all penguins, the male must somehow manage to stand on the female's back for mating to occur. Clearly he needs her help.

The penguin mating dance begins as the male approaches the female with a hunched, submissive walk,

instance, make deep face-to-face bows with one another, accompanied by powerful and rhythmic honking duets.

Rockhoppers and Macaronis, by contrast, perform energetic "ecstatic displays" in which mated pairs join together in rollicking bouts of ritualized head-waving and flipper-wagging. Displays such as these serve to reinforce the strong bond between paired birds and synchronize their time-sensitive breeding cycles.

Although these two Adelies appear to be holding flippers, this is no romantic moment. They were only passersby on the edge of a busy colony in the South Orkney Islands, each one looking for its mate.

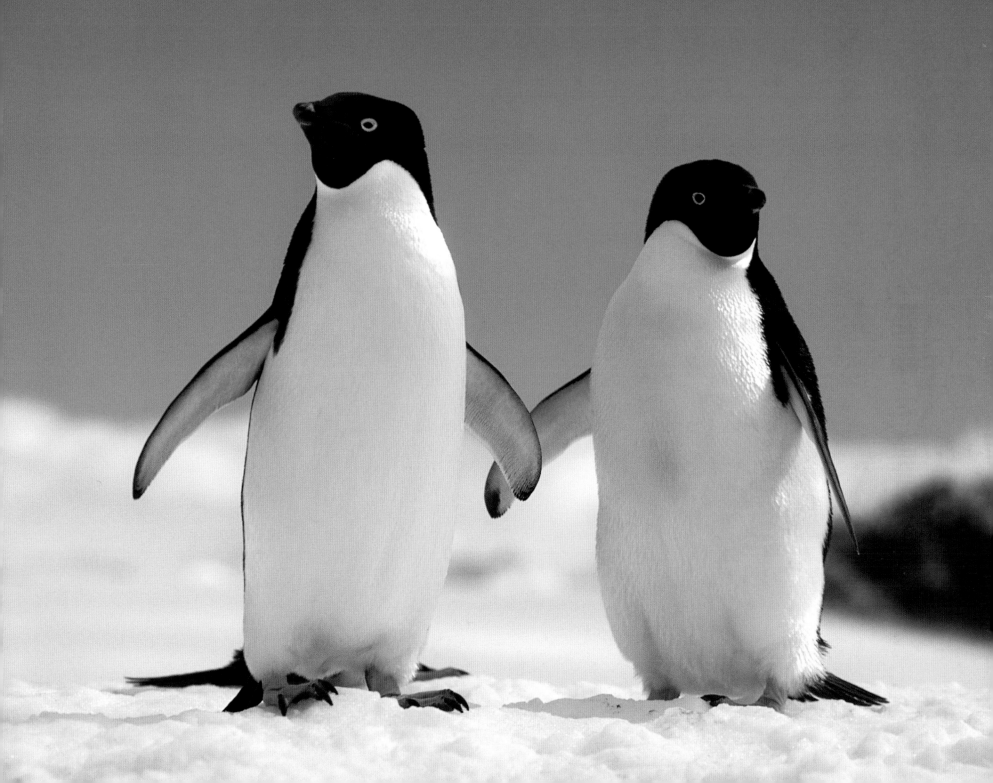

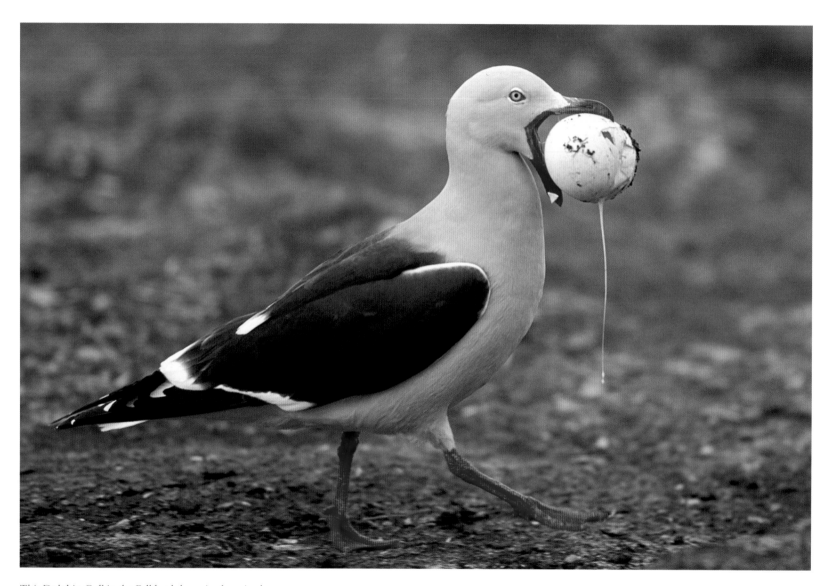

This Dolphin Gull in the Falklands has seized a prized meal: a fresh Gentoo egg. The seasonal abundance of the penguin colony is a boon to predators like these; they must work harder for their food when the penguins depart.

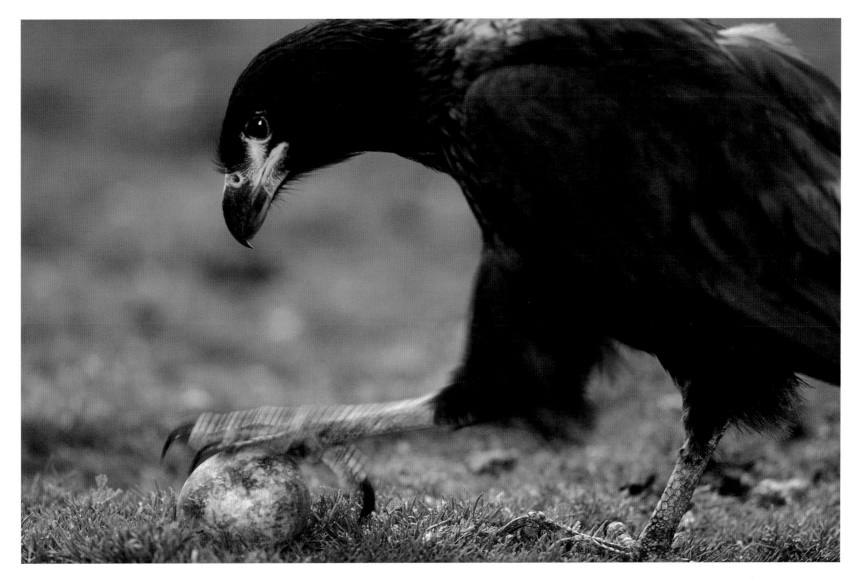

Having dislodged a Gentoo egg from its nest, a Stri-
ated Caracara tries to break it open with its foot. It
took twenty minutes to crack—at which point it was
promptly stolen by another bird.

apparently designed to stimulate her interest—and her cooperation. He strokes her with his flippers, which are vibrating madly in an ecstatic quiver, and presses his body against her back. If she warms to the idea, the female lowers herself to the ground, inviting the male to climb aboard.

The act itself is often very tender, accompanied by lots of bill contact, quiet mewing, and a certain amount of mutual nibbling around the head and shoulders. It generally lasts no more than a minute or two, at which point the male dismounts. At this point, behavior varies; some pairs continue billing and cooing, or spend a few moments adjusting their makeshift nest. Others may simply fall asleep.

Successful mating is, of course, the object of all this effort, and the months of preparation and sacrifice that lead up to it. But for most penguins, the really hard work is just beginning. Raising one or two chicks—no penguins have more—demands all the energy and hunting prowess of both parents.

Breeding strategies vary widely between species, largely because of the very different conditions the birds confront. No two penguins better demonstrate this than the Adelie and Emperor, the only two species—contrary to popular expectation—that nest below the Antarctic Circle. For although they nest at the same latitudes, sometimes quite close to one another, their breeding calendars could not be more dissimilar.

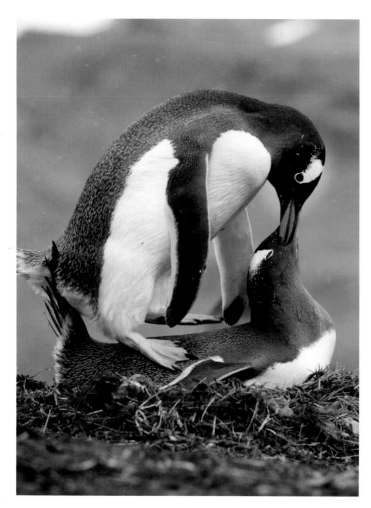

A pair of Gentoos shares a tender moment on South Georgia. The male's job here can be surprisingly challenging; he must climb onto his partner's back and stay there throughout. For her part, the female must hold still or risk throwing him off.

While mist clings to the rugged peaks of South Georgia, vast throngs of King Penguins gather along a freshwater stream. Many are molting, a process which may require their going without food for a month, and losing 44 percent of their body weight.

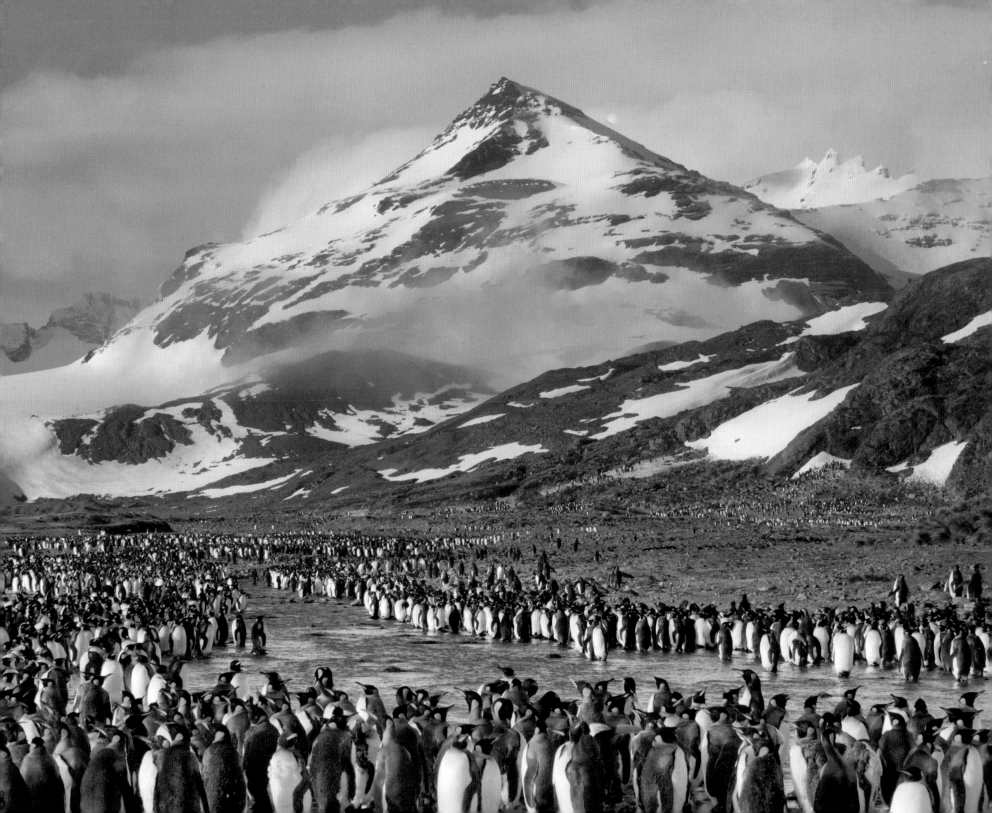

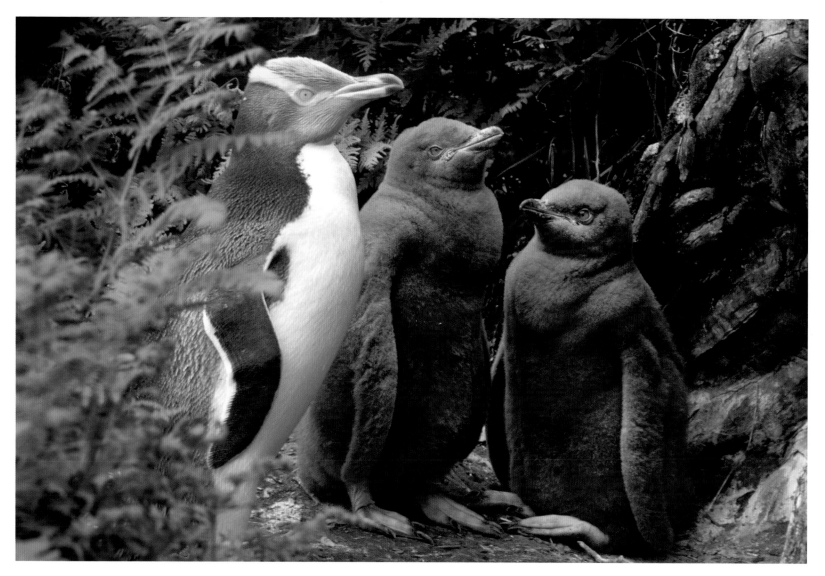

In the absence of predators, these young Yellow-eyed
Penguins on Enderby Island are twice as likely to sur-
vive to adulthood as those on the nearby New Zea-
land mainland, where deadly cats and rats abound.

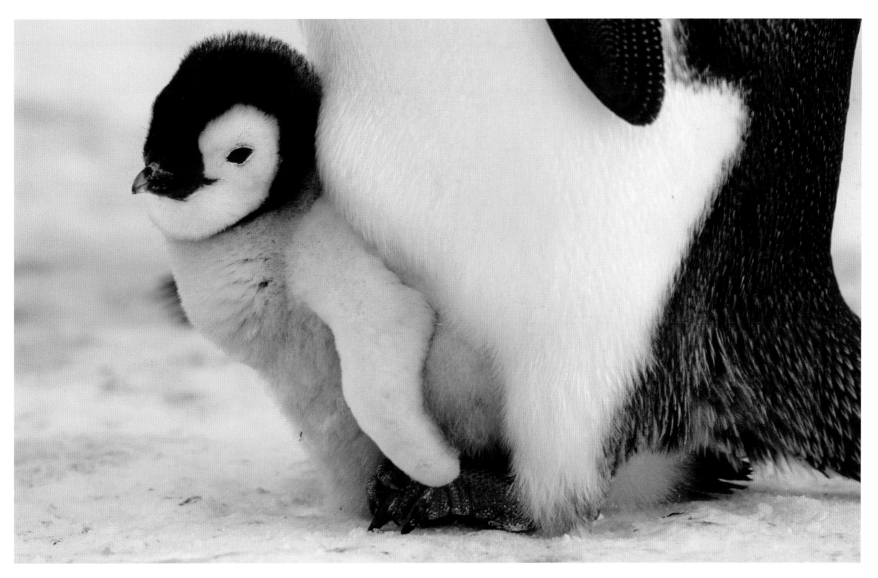

This was one of the last chicks still clinging to its parent's feet when I visited the Emperor Penguin colony in Atka Bay—in Antarctica's remote Weddell Sea. Only a handful of people have ever witnessed the hatching of an Emperor egg, an event that takes place in the icy twilight of the Antarctic winter.

For Adelie Penguins, breeding is a race against time. Because they nest so far south, the season is very short: winter snow usually still covers the ground when they arrive on the colony, in September or early October. Courtship and egg-laying, therefore, must take place soon afterwards. Incubation lasts about thirty-three days.

Adelies normally lay two eggs, although they usually manage to raise only one chick to fledging. Once the eggs have hatched, the adults must work around the clock to bring back enough food for their ravenous chicks. Male and female will alternate every day or two for the first month, one staying behind to protect the chick while the other feeds at sea. This goes on for seven weeks, until the chick is ready to fledge, departing just as the southern summer comes to a close in late February or early March.

If breeding starts too late, the young will not survive the first autumn storms. If it starts too early, lingering ice may keep food too far from the colony. And in both cases, birds out of step with the rest of the colony are more vulnerable to predators. For that reason, breeding in Adelies is intensely synchronous, meaning that the majority of birds in the colony will be at the same stage of breeding at the same time.

Emperor Penguins, on the other hand, operate on a completely different schedule, and are just arriving at their colony as the last Adelies begin heading north. The reason? Emperors are twice the size of Adelies, and could not possibly raise their huge chicks to adult size within the same five-month win-

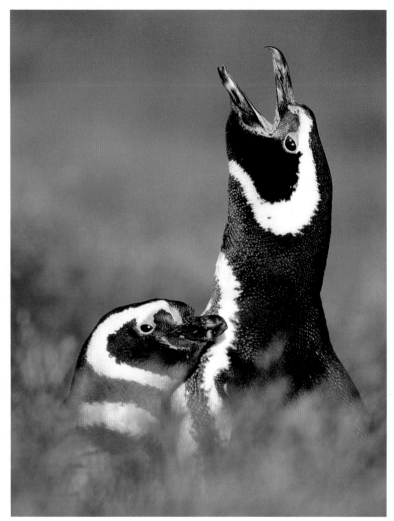

A penguin colony is never a quiet, contemplative place: it is an orgy of sound and almost constant activity, day and night. Waking up to the braying sound of these Magellanics can make you think you're surrounded by a herd of donkeys.

A King Penguin chick begs for food by pecking insistently at its parent's bill. Kings have the longest breeding cycle of any penguin, taking a full twelve months to complete the task. For that reason, they normally only breed every other year, and spend more than half of their adult lives raising young.

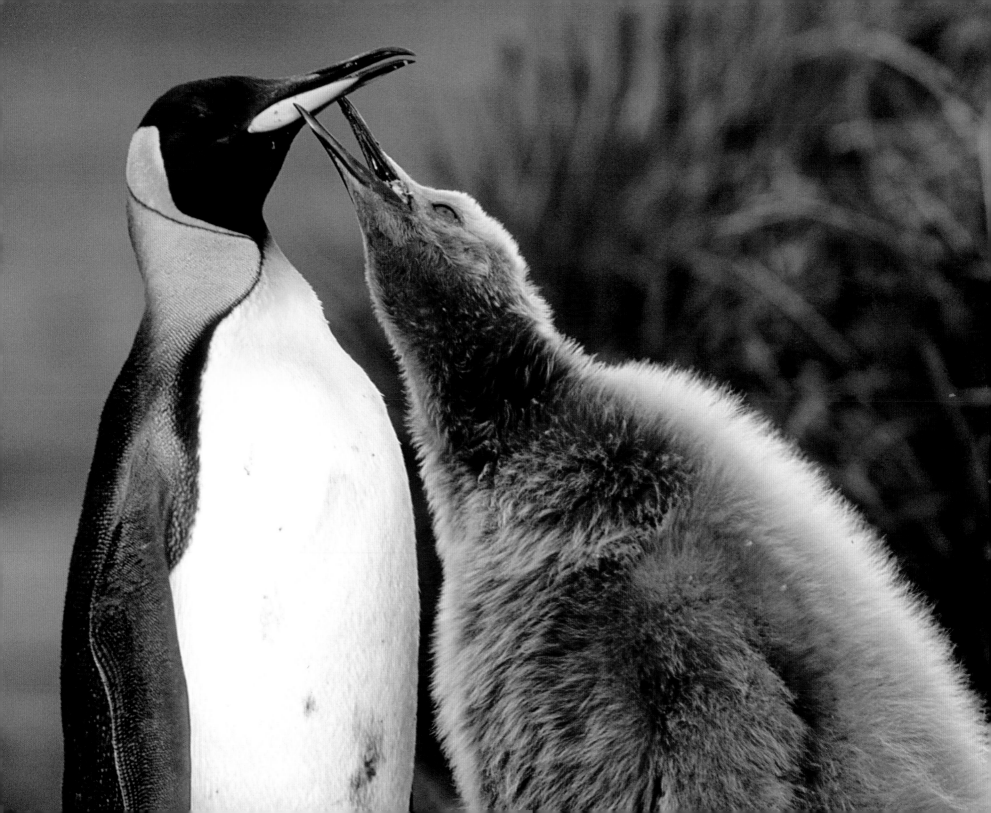

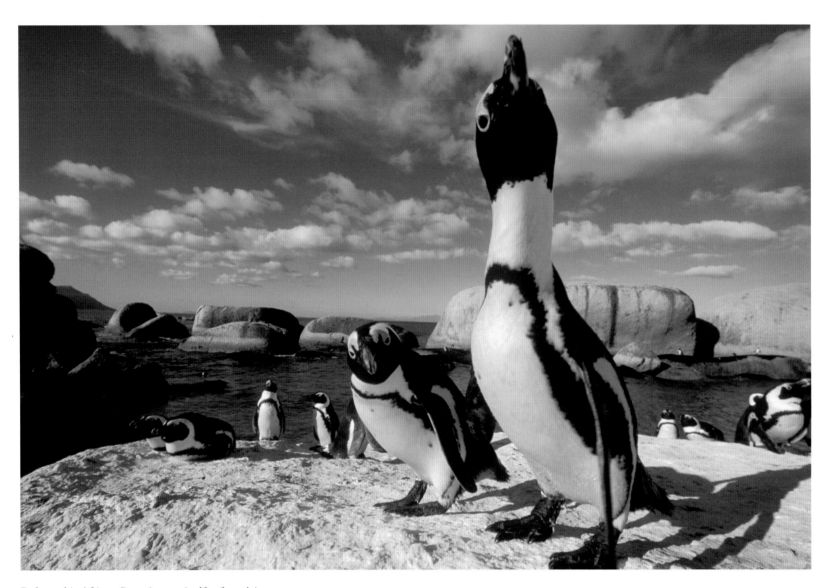

Perhaps this African Penguin saw itself reflected in my lens, or was simply puzzled by the shiny glass. Despite their fabled tolerance for people getting close, they retain a clear sense of personal space.

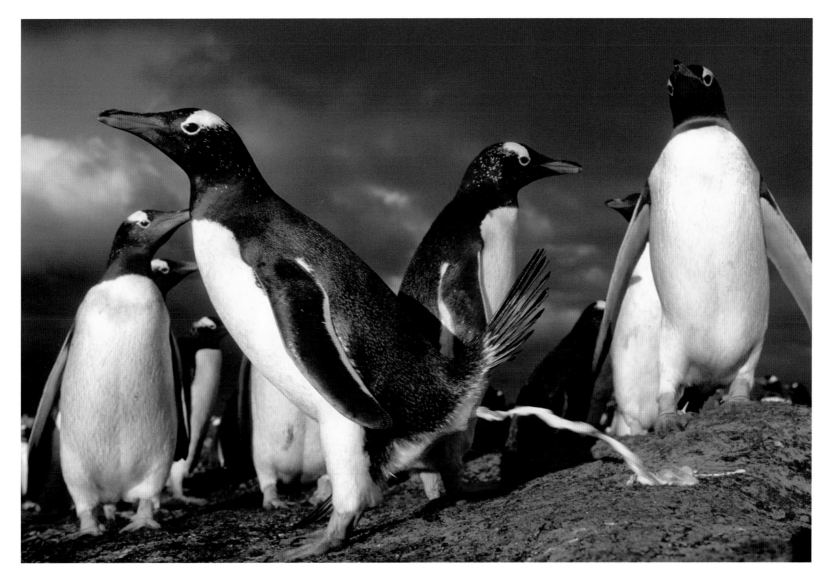

To expel waste, a Gentoo Penguin in the colony tries to aim high. With luck, this will prevent it from fouling its own nest. A neighbor, however, may not be so lucky.

dow as Adelies. Instead, they have evolved a unique—almost incredible—breeding calendar, spreading the process out over the course of an entire winter, through the months of total darkness and almost unimaginable cold.

This is the magnificent story told so well in the feature-length film *March of the Penguins*. To ensure that their chicks will fledge the following summer, the Emperors must arrive in the colony by early April, when autumn brings ever-shortening days and bitter cold. In May, just as the sea begins to refreeze around the Antarctic, the female Emperor lays a single, enormous egg, passes it to her mate—and promptly leaves.

She will spend the next two months at sea, feeding and gaining strength, and avoiding the depth of winter. The male, meanwhile, is not so lucky. Carrying their precious egg on his feet, he shuffles slowly about in a constant effort to stay warm, despite the howling wind and bitter cold. The egg itself is kept safe by a special flap of warm skin that the male drapes over it.

Male Emperors spend the winter this way, huddled together with hundreds, sometimes thousands, of other males, all protecting their own eggs. To conserve heat and energy, the males huddle together, each bird trying to break the wind by standing behind his neighbor. The result is a constantly shifting mass of huddled penguins, with those on the windward side slowly shifting to the lee.

By July, when the eggs hatch, the male Emperor will not have eaten anything for nearly four months, and will have lost 35–40 percent of his body weight. Near starvation, he must wait for the female to return with

Although this adult Emperor seems surrounded by a large family, only one chick is its own—this is as many as an Emperor can ever hope to raise. Even so, as many as 90 percent of those chicks will die in their first, difficult year.

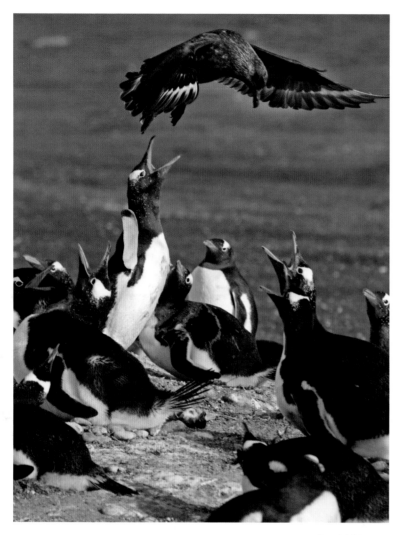

Skuas simply hover over a Gentoo colony, just out of reach, waiting to snatch a serendipitous meal. This skua maintains a feeding territory and will fiercely defend "his" penguins from competitors.

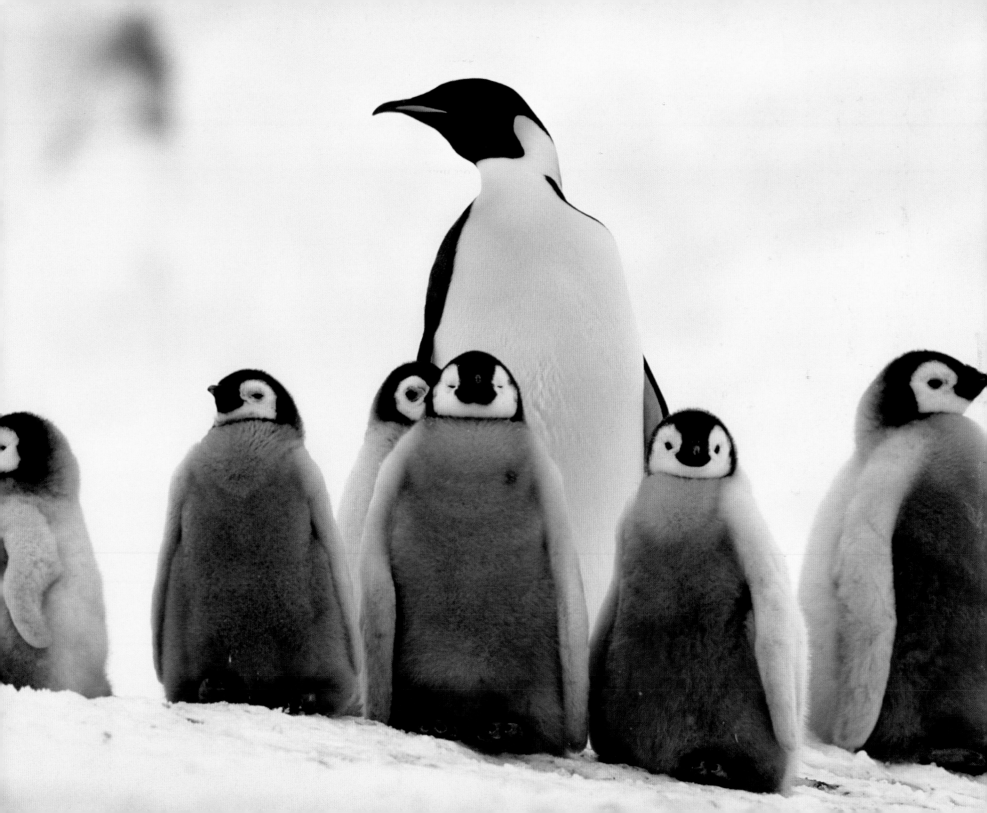

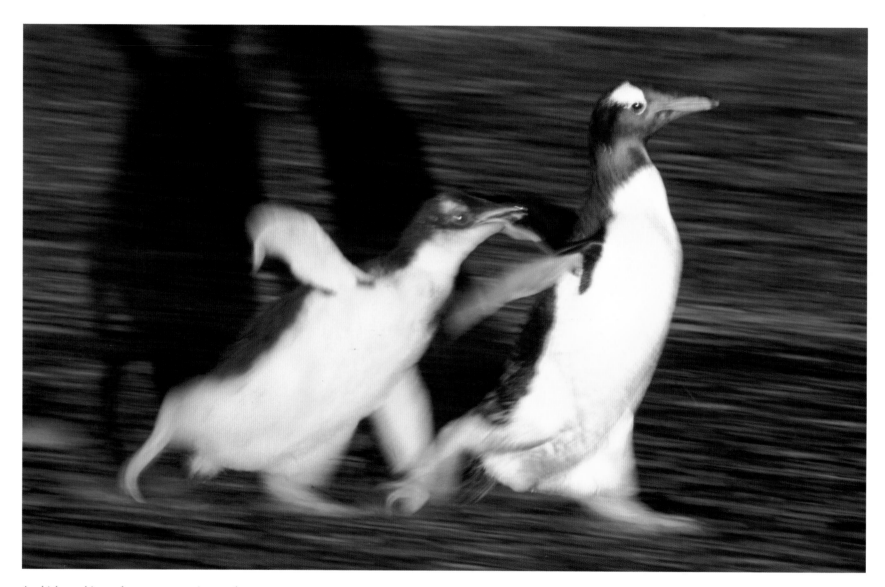

As chicks get bigger, they get more active—and more annoying. No longer content to sit on the nest and wait to be fed, this baby Gentoo chases its parent through the colony, hoping to get a meal.

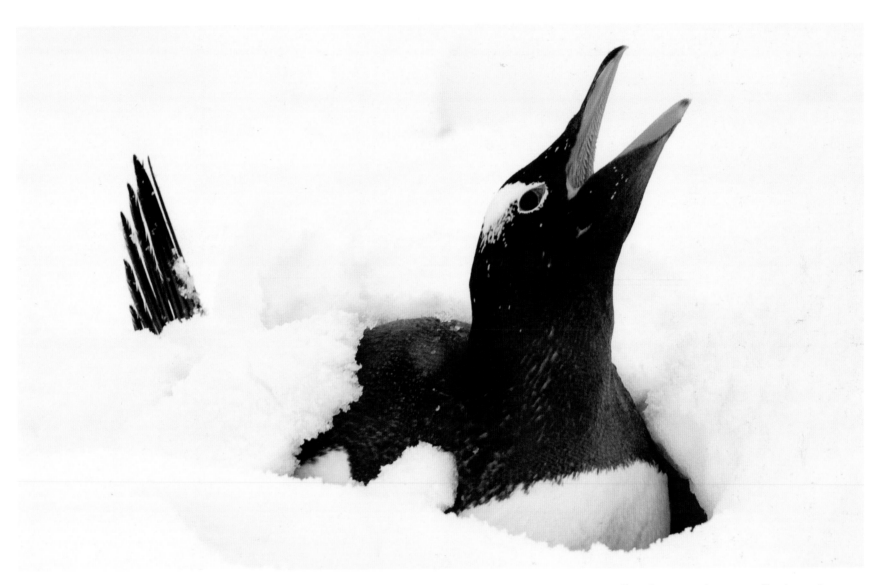

Penguins are tenacious parents. Despite a spring snow-storm that has threatened to bury her, this Gentoo continues to incubate her eggs. Penguins prefer windy or exposed nest sites that are likely to be clear of snow early in the season, but some years, the snow lingers everywhere.

food for their newborn chick. Incredibly, the female normally returns within a day or two of hatching, her stomach full of food, often having walked many miles over the ice in total darkness.

Occasionally the female is late, but even here there is still hope. In the absence of food, the male Emperor is able, even in his vastly reduced state, to feed the chick with secretions from his stomach walls. This can last for up to ten days; the chick can actually double its weight on this mixture. If the female does not return by then, however, the male must abandon his chick and head to sea.

Normally, males and females alternate care and feeding of the chick until it is ready to fledge, five months later. By this time, the sea ice has hopefully melted to the point that open water is relatively close to the colony, and the Emperor chicks can head off to start their own lives at sea.

As it is for all birds, that first year of life for a young penguin is its most perilous. Adult penguins eventually abandon their young on the colony, and only hunger and instinct drive these young birds to the sea. Then, to survive, they must be able to find their own food, and to navigate in an ocean they have never seen, all without the benefit of their parent's guidance. Not surprisingly, as few as 10 percent of young Emperor Penguins are thought to survive their first year, compared to a little more than half of Adelie chicks.

Yet by the time that penguins return to breed for the first time, generally some two to five years after fledging, they have learned a great deal. The survival rate for adult birds is very high; as many as 95 percent of adult Emperor Penguins breeding one year will be back again the next.

Clearly, despite the extraordinary rigors they face in finding food, avoiding predators, and raising their young, penguins are a remarkably successful group of birds. Some species continue to increase in numbers. But as we approach the new millennium, they may confront their greatest challenge—human beings.

A massive red tide in 2002 poisoned thousands of adult Gentoo Penguins in the Falkland Islands. Was this a signal of a warming climate? No one can say, but whatever the cause, squads of hungry Johnny Rooks made quick work of the dead and dying.

Are these Adelies immune to the beauty that surrounds them? Probably, but it's a pity, since the birds here at Cape Hallett in Antarctica's Ross Sea enjoy some of the most spectacular scenery in the world.

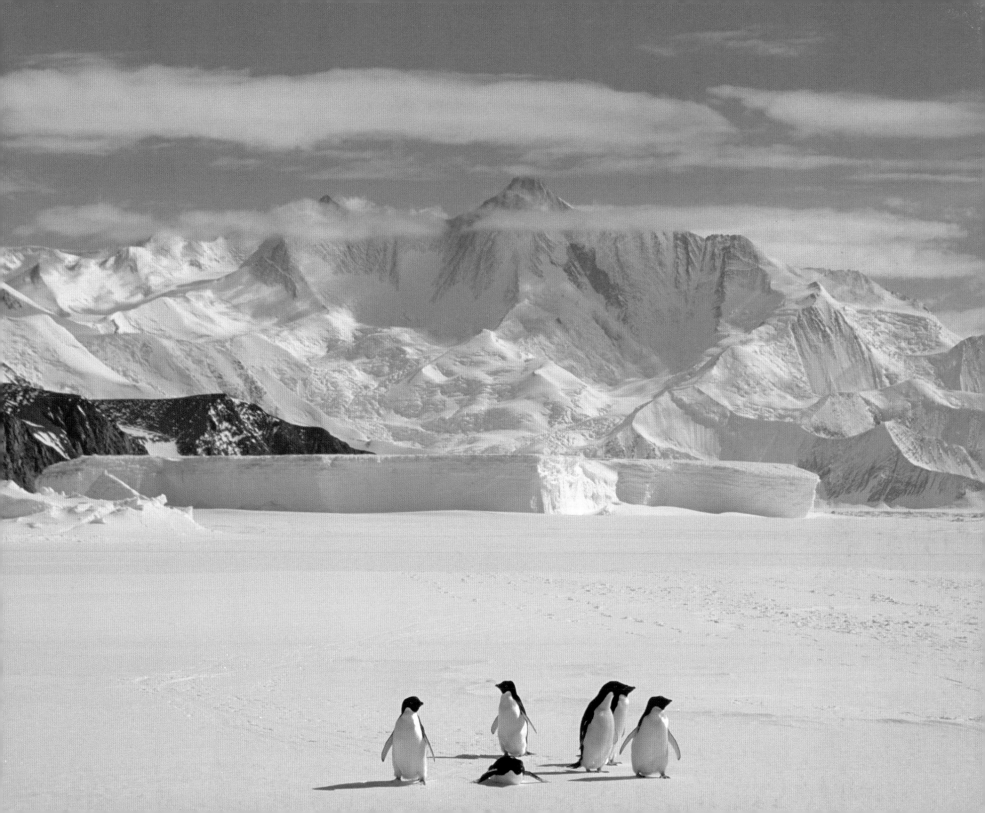

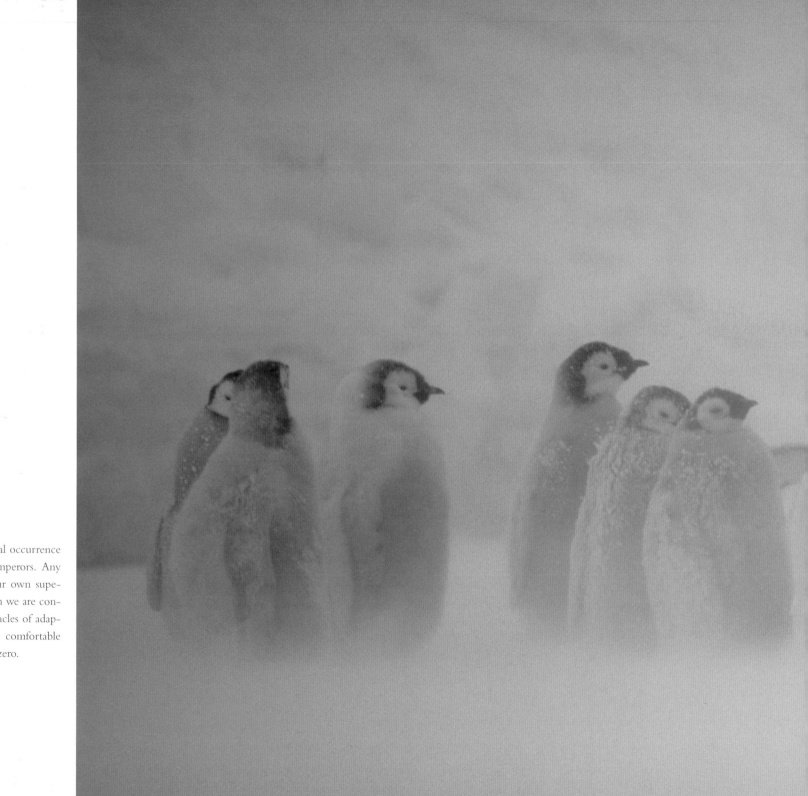

A blizzard is a normal occurrence for these young Emperors. Any remnant belief in our own superiority vanishes when we are confronted by these miracles of adaptation—relaxed and comfortable at 60 degrees below zero.

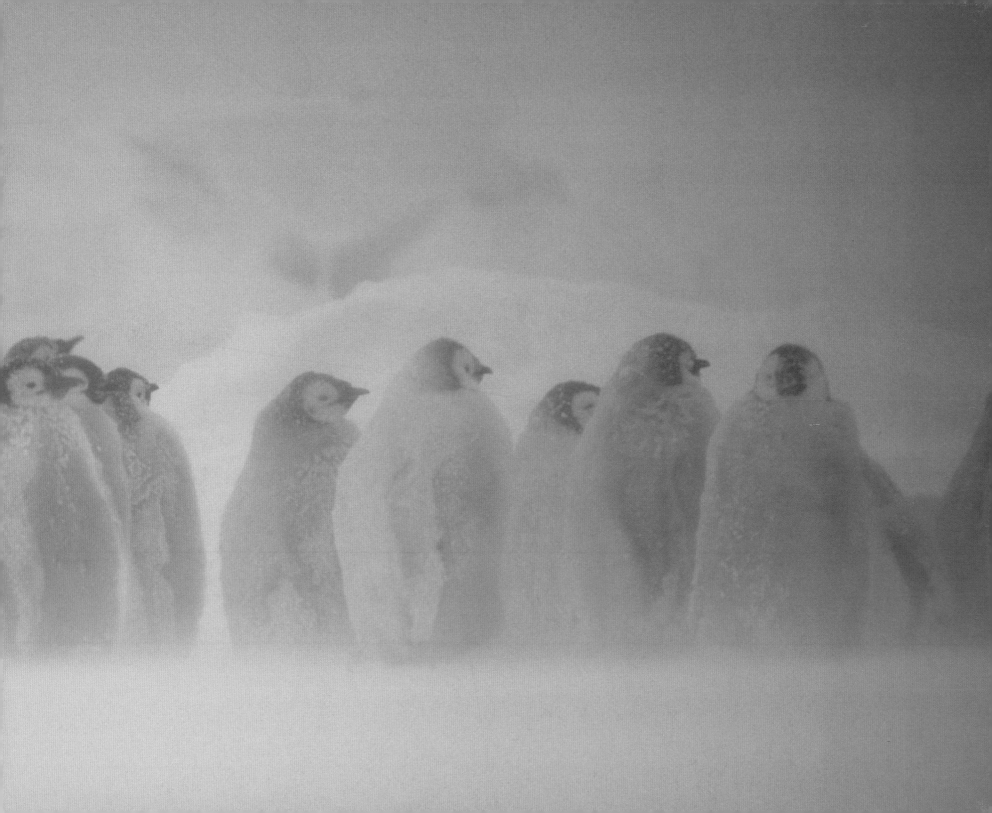

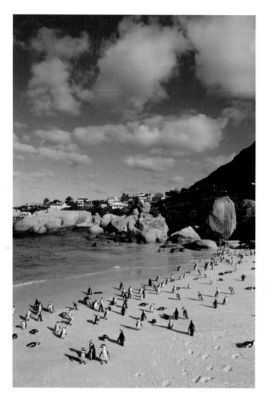

South of Cape Town, African Penguins—not tourists—line a perfect white sand beach. These "suburban penguins" live around and under private homes, but are enjoyed, and protected, by the local people (though sometimes they complain about the noise).

THE HUMAN FACTOR

History has been kind to penguins. For most of their long tenure on Earth, perhaps sixty million years, they have confronted only the natural challenges that face all species: those of feeding themselves, raising their young, and escaping hungry predators. They have endured changes in climate, drifting continents, and have adapted to some of the harshest living conditions on the planet. Simply said, penguins are one of the oldest and most successful bird families that has ever lived.

Penguin species have gone extinct in the past, of course, including *Anthropornus*, a penguin giant from the late Eocene period in New Zealand, around forty million years ago. The tallest known fossil penguin discovered so far, it stood more than 5 1/2 feet tall (1.7 meters) and weighed up to 200 pounds (90 kilograms). There were many others, of course, now gone. Indeed, the fossil record suggests that penguins were once much more numerous, and more diverse, than they are today.

We may never know what caused *Anthropornus*, or any of what may be hundreds—maybe thousands—of species, to disappear. Changes in climate and oceanic conditions are the most likely causes: times change, and so do penguins. We do know, however, that no penguins have ever gone extinct at the hand of humans—at least not yet. For although we did not invent extinction, we have certainly mastered the technique.

Humans and penguins may have known one other for millennia in places where we might have overlapped: Southern Africa or Patagonia.

Tourists are now able to travel to places that were once only the domain of explorers. Here, three Emperors stand by impassively as a hundred tourists disembark from the *Kapitan Khlebnikov*, a Russian icebreaker. These are almost certainly the first humans these penguins have ever encountered.

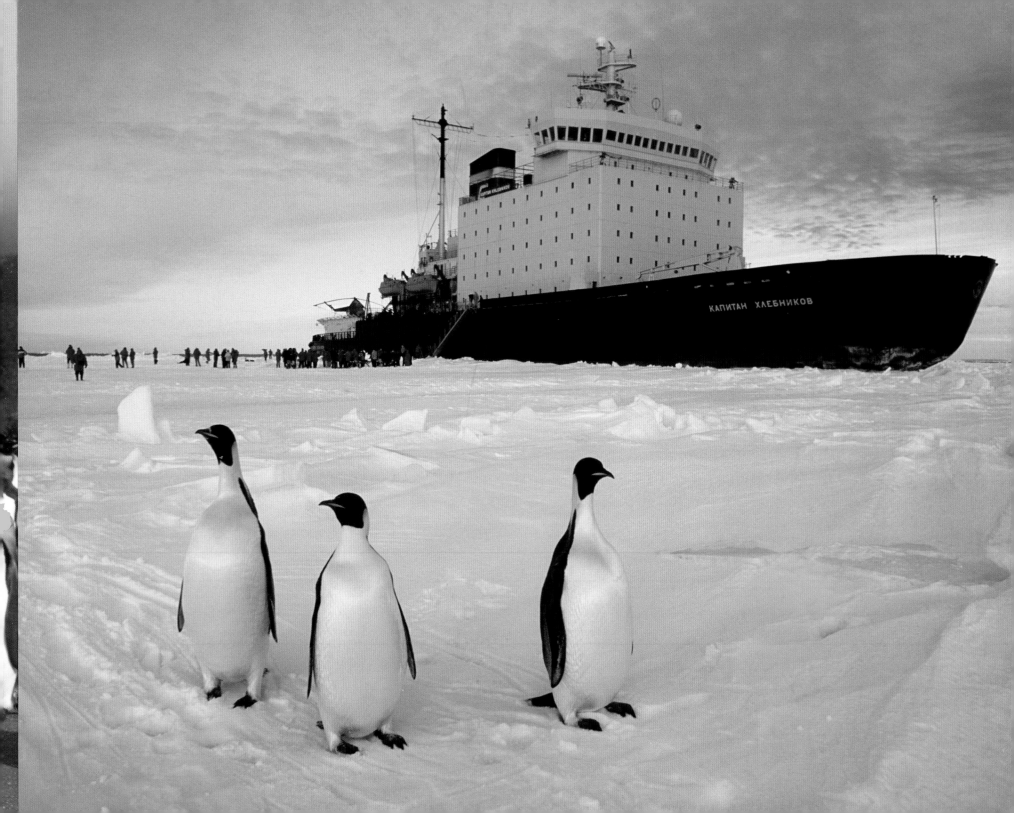

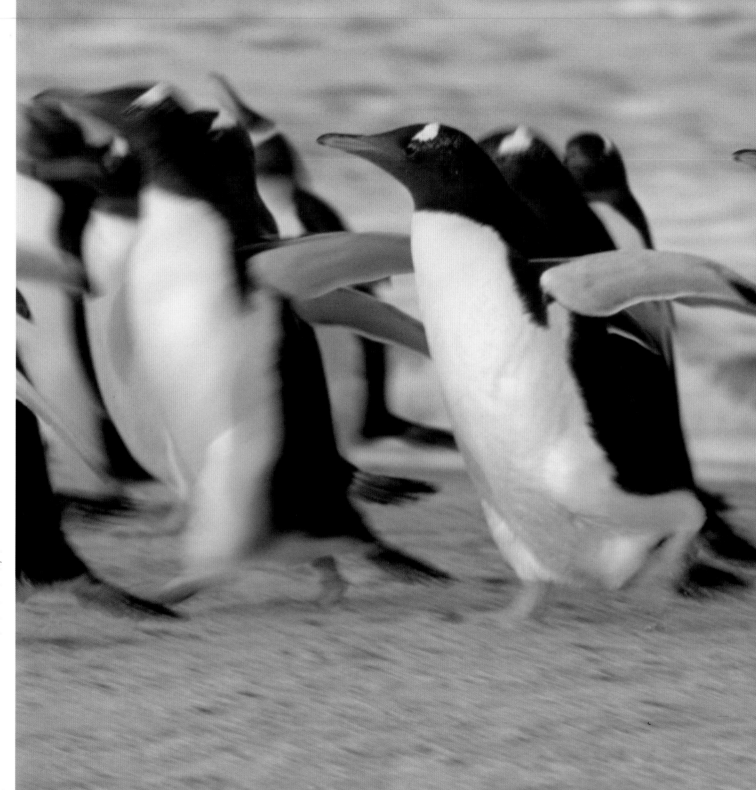

The morning commute, Falklands style. All day long, with a sense of frantic purpose, dashing Gentoo Penguins form a steady stream to and from the colony. Gentoos often seem to be in a hurry, as if they see no reason to simply walk.

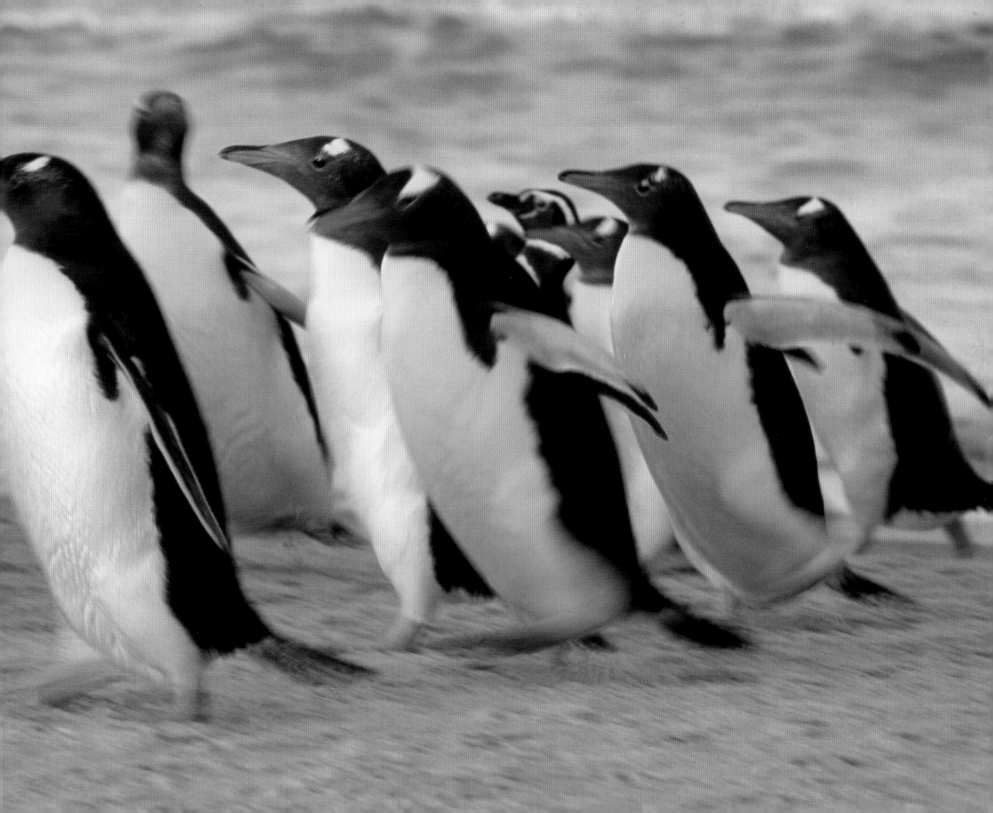

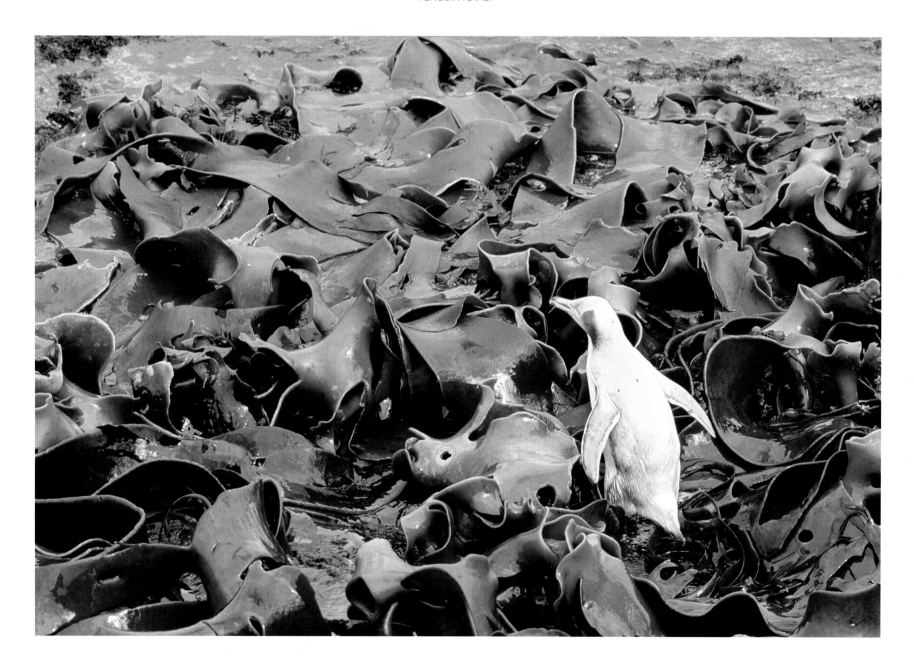

On the Pacific coast of South America, meanwhile, a brisk trade in penguin guano, a valuable source of fertilizer, brought the Humboldt Penguin to the edge of extinction. Guano collectors stripped the nitrogen-rich soil from offshore breeding islands, leaving these burrow-nesting birds nowhere to breed. In addition, a growing commercial anchovy fishery off the Peruvian coast depleted stocks of the birds' primary food, reducing populations even further.

And as if that weren't enough, Humboldts were also widely collected for international zoo collections, largely because they can be kept outdoors in almost any climate. More than nine thousand penguins had been taken from the coast of Peru before the government stepped in to outlaw the trade.

Sadly, the list goes on and on. And although the days of outright slaughter of penguins have thankfully

A Yellow-eyed Penguin navigates some thick kelp toward the open water. This bird is "leucistic," lacking some of the black pigment so typical in penguin feathers. Although this bird has grown to adulthood, this coloration can be a disadvantage, drawing the attention of predators.

passed, penguins still suffer from the effects of human activity almost everywhere in the world. The fact is, several penguin species today will almost certainly vanish in our lifetimes if we do not take strenuous measures to protect them.

Among these is the Yellow-eyed Penguin. The coastal forests of southern New Zealand, where these birds nest, have largely been cleared for farms and grazing land, leaving penguins few places to go. In addition, their eggs and chicks increasingly fall victim to introduced predators.

When the ancient Polynesians first arrived in New Zealand, there were no native mammals—except for a few bats. As a result, there was an extraordinary number of flightless birds, including penguins. (Another argument for penguins having evolved here.)

After James Cook first landed in New Zealand in 1769, British settlers soon arrived, bringing with them domestic dogs, cats, and rats, followed by stoats and ferrets to catch those rats. All were only too happy to plunder the easily accessible nests

Two Gentoos must trudge up a well-worn path to reach their ridge-top colony, still buried under spring snow. A warming climate can sometimes have unexpected local effects, including heavier snowfall and wetter conditions during the nesting season.

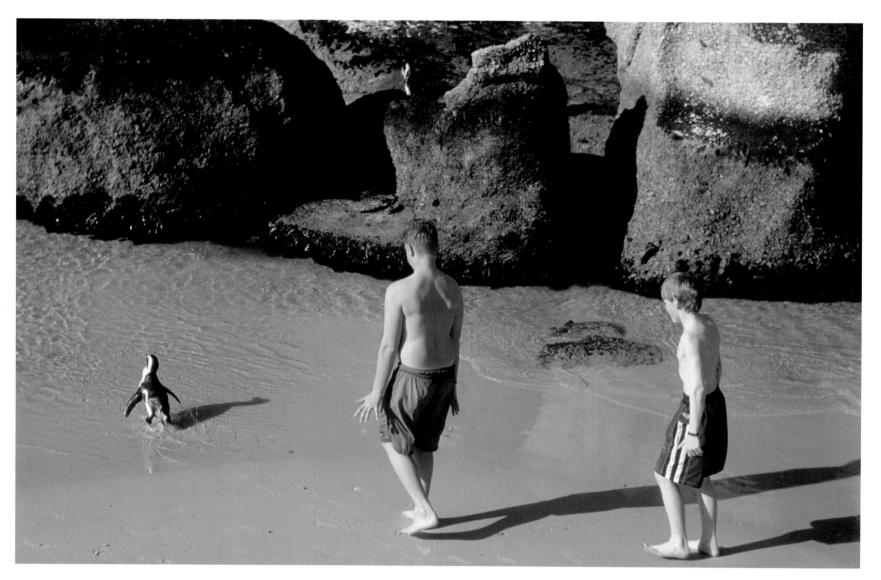

This African Penguin has to share the beach with
human holiday-makers, including these two boys
trying to mimic the bird's distinctive waddle.

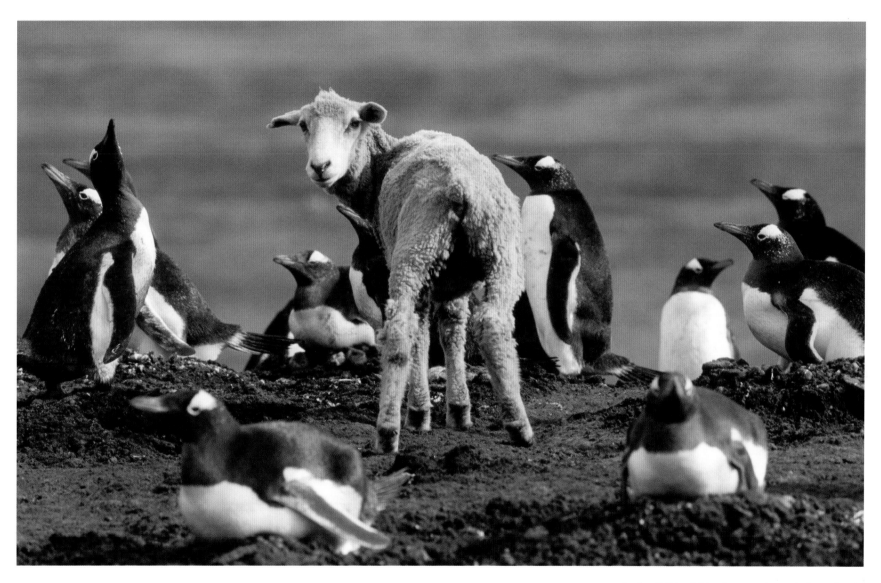

In the Falkland Islands, penguins and sheep live in uncomfortable proximity. The ewe, being herded to a new pasture, took a shortcut through a Gentoo colony but appears confounded by the croaks—and sharp beaks—of some rather annoyed penguins.

111

Sunrise casts long shadows behind this group of King Penguins on a South Georgia beach. At three feet tall, they are second in size to the Emperor, with whom they share many physical traits.

In June of 1994, the oil tanker *Apollo Sea* went down near Cape Town with all hands on board, right between two major penguin nesting colonies on Robben Island (where Nelson Mandela spent his many years as a political prisoner) and nearby Dassen. Worse yet, the spill happened in the middle of the breeding season, and tens of thousands of penguins were caught in the spreading, deadly slick.

Oil kills penguins by reducing their ability to insulate themselves from the cold water in which they live. Those birds that washed ashore alive were taken to nearby SANCCOB (South African National Foundation for the Conservation of Coastal Birds), which specializes in treating injured and oiled seabirds, especially penguins. SANCCOB volunteers sprang into action and cleaned and treated ten thousand penguins for two weeks, successfully releasing more than half of them back into the sea.

A remarkable percentage of those released birds are believed to have survived, but such accidents are almost certain to happen again. In the confrontation between man and penguin, the penguin almost always loses.

Careless release of oil from ships has also been blamed for a 20 percent reduction in the numbers of Magellanic Penguins in one area of coastal Argentina. Plans to build a major oil port in the Falkland Islands, home to over a million nesting penguins, have conservationists deeply concerned.

Yet people are not always the clear villains. Occasionally, large numbers of penguins die without a clear explanation. In July 2012, more than seven hundred young Magellanic Penguins washed ashore dead in southern Brazil. To scientists who examined them, the birds looked well-nourished and without any visible signs of oil contact. As of yet, no one knows what caused this sudden, massive mortality.

Despite their reputation for black-and-white uniformity, some penguins are beautifully colored. Perhaps the most stunning of all is the King Penguin, with its lustrous "cape" and rich orange auricular patch.

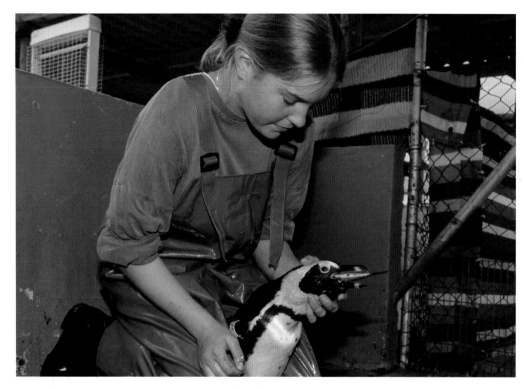

A volunteer at the SANCCOB rehabilitation center near Cape Town feeds an oiled African Penguin before it is released. Penguins treated here have as much chance of long-term survival as non-oiled birds—a miraculous achievement.

Rockhopper Penguins, meanwhile, have seen a dramatic decline at several locations around the world in the past few decades, and although many people are quick to blame overfishing or pollution, the answer may not be so simple. In the Falkland Islands, where Rockhoppers were thought to number almost 7 million in 1933, there may be fewer than 700,000 surviving today. A similar decline has been observed on Campbell Island, south of New Zealand. The only trouble is, neither island group has a large commercial fishery nearby, or much in the way of commercial shipping.

These kinds of findings, repeated in many parts of the Southern Hemisphere, suggest that the greatest impact on penguin populations around the world may come from the effects of global climate change. Changes in climate have almost certainly caused the decline and extinction of penguin species in the past; they may do so again. Only this time, we may be contributing to the process.

Most climate scientists have argued that the impact of changing climate would be most profound at the poles, where even modest changes in annual temperature can alter ice, weather, and ocean currents. This does not mean that rising temperatures show a predictable, or linear, effect on penguin populations. Research in Antarctica over the past forty years has shown that while some penguin populations are decreasing, others are increasing.

A Little Penguin incubates its egg in a bed of its own feathers on Australia's Kangaroo Island. A thriving tourist industry has grown up around the Little Penguin in Australia, where thousands of people every year gather at dusk to watch these birds emerge from the sea.

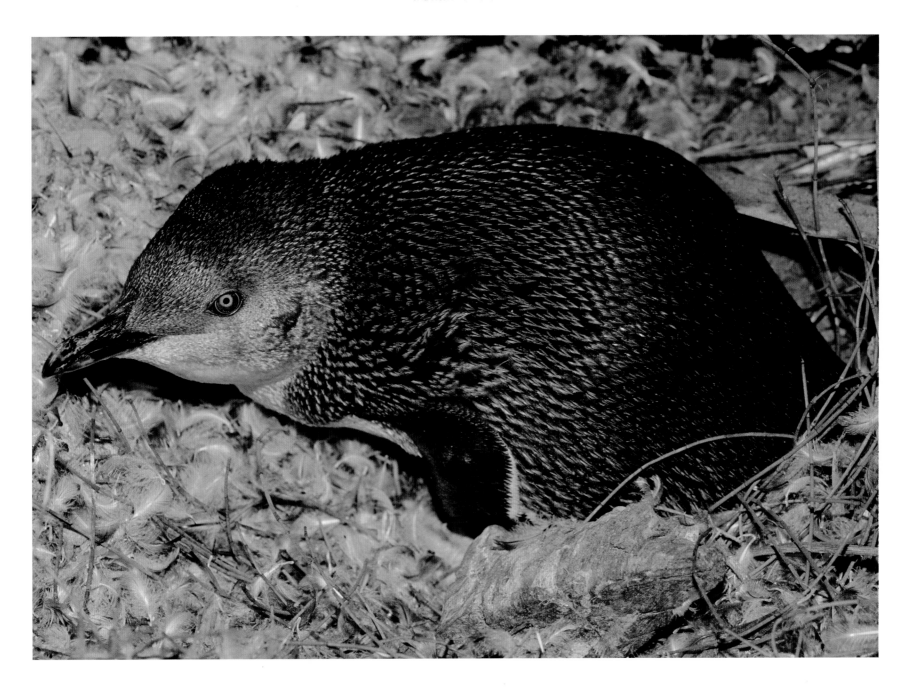

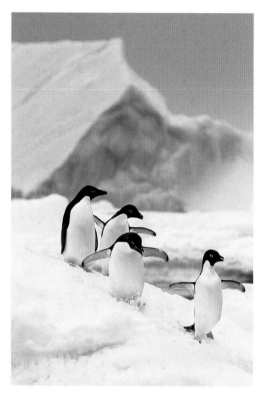

Struggling to stay upright, four Adelie Penguins climb down an ice floe that has blocked their way to the water. The reduction of annual sea ice has already changed the population dynamics of Antarctic penguin species.

Climate change has had some surprising effects in Antarctica. In some areas, the extent of annual sea ice is actually increasing, despite higher global temperatures. Changes of only a few degrees can cause variations in local ice cover, which, in turn, affect the feeding success of Adelie Penguins, which depend on the pack ice for their food.

Emperor Penguins, meanwhile, may be forced southward as temperatures increase. In the northern part of their range, warming has reduced the extent and duration of fast ice—sea ice that remains attached to land—on which almost all Emperors breed. Colonies there are getting smaller, while farther south they are holding their own, or possibly growing.

This suggests that penguins are already adapting to changes in their environment. Yet this adaptability, and southerly migration, may have its limits. If warming continues at current rates, and sea ice cover continues to shrink around Antarctica, there may eventually be nowhere left for these penguins to go.

Is there anything we can do to help penguins survive? Faced with enormous challenges like climate change, industrial fishing, pollution, and habitat loss, it is difficult to know how individuals like you and I can make a real difference. Clearly, we must find ways to preserve the habitat and resources on which penguins depend, but this sets the needs of penguins directly in conflict with the interests of humans. Are we willing to reduce commercial fishing? Can we eradicate nonnative predators, including feral cats? Is it possible to limit coastal development to save breeding habitat? These are tough choices, but if we want penguins to survive, these are the decisions that we will have to make.

At dawn, a single African Penguin strides toward the sea from its nest among the granite boulders of the Cape Peninsula. Despite the warm climate of the cape region, the cold Benguela Current just offshore sweeps rich food up from the Antarctic.

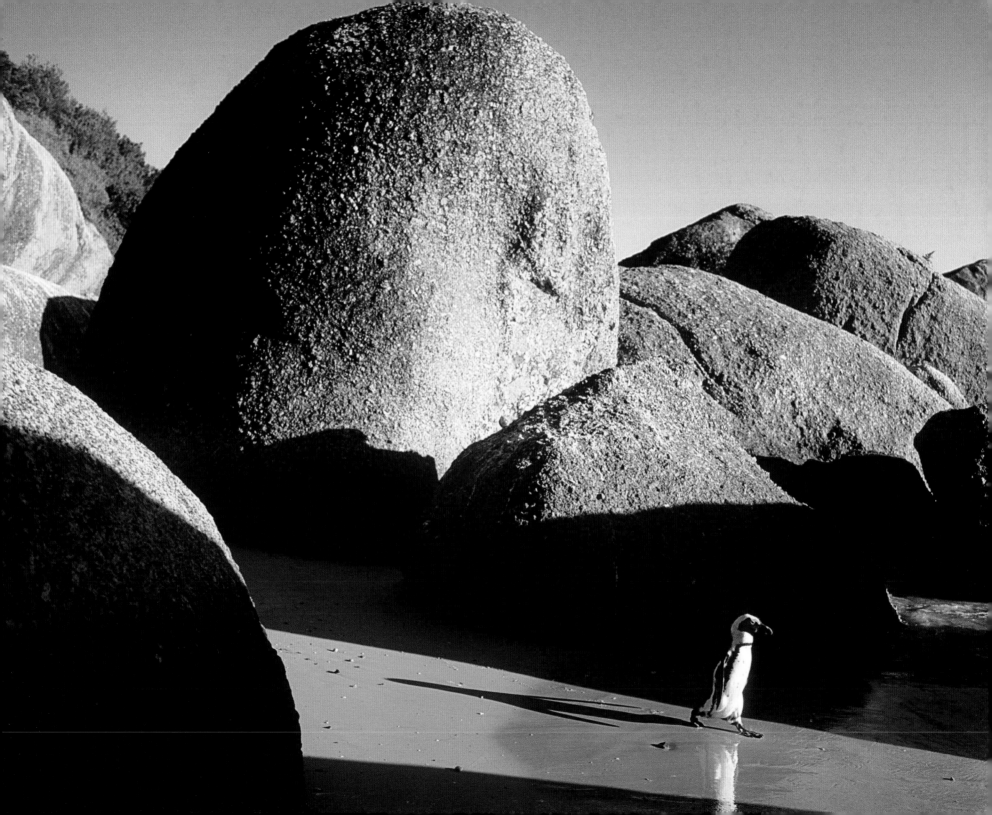

Tracks in the snow reveal the truth of an Adelie's gait: its long tail not only drags behind, but waves back and forth as the penguin wobbles.

WHERE TO SEE PENGUINS

One way to help penguins is simply to learn more about them and the world in which they live. There are, of course, many zoos around the world with penguin exhibits. Many of these house temperate species such as Magellanic and Humboldt penguins, which are relatively easy to care for in warm climates. Only a few, including Sea World in San Diego and the Central Park Zoo in New York, have the large, refrigerated exhibits needed for more cold-loving species, like Emperors or Gentoos.

If you do go to the zoo to see your local penguin, be sure to be there for feeding time. Watching penguins simply standing around, or sleeping, is fine—but at feeding time they are typically more alert and active, and can often be seen in the water, where they are simply breathtaking.

For anyone fortunate enough to visit a real penguin colony, the first thing you will notice, apart from the noise and the appalling smell, is the birds' striking fearlessness. Penguins are not tame: that word implies that they have grown accustomed to us and lost their fear. That's not the case; the key point about penguins is that *they never had any fear in the first place.* This phenomenon is sometimes described as "ecological naiveté," a colorful way of saying they evolved with no knowledge of humans and no instinctual fear of us. (A trust that has proven, as we have seen, vastly misplaced.)

The result is, however, that it is often very easy to get close to some species of penguins. They look at us with only minimal interest, as if

One of the greatest penguin locations on earth is the remote island of South Georgia, on the edge of Antarctica. Here, vast gatherings of wildlife are joined with dramatic mountain scenery.

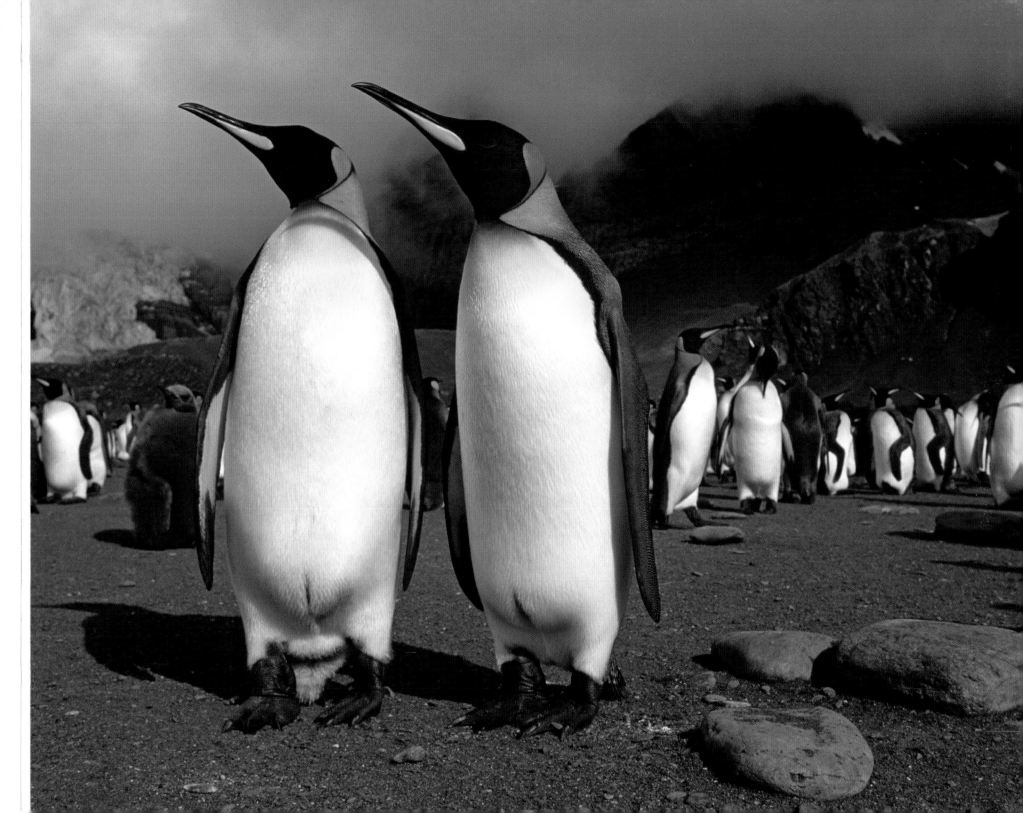

in most organized tours: strap on a mask and snorkel and you just might get a chance to swim with a penguin.

THE FALKLAND ISLANDS

This remote island group is not easy to get to, but it is one of the most wonderful places in the world to see penguins, especially the King, Gentoo, Rockhopper, and Magellanic. Many cruises to the Antarctic stop here for a day or two on their way south, but few stay long enough to really enjoy the place.

ANTARCTICA

The most dramatic place, of course, to see penguins in the wild is the Antarctic itself—home to the Adelie, Emperor, Chinstrap, Gentoo, and Macaroni. However, you aren't likely to get there on your own. You'll probably have to join a cruise of some sort, most of which are very expensive. For that reason, if you're only going to spring for one Antarctic trip, make sure your itinerary includes the island of South Georgia, home to the King Penguin and simply one of the greatest wildlife gatherings on the planet.

It is extremely difficult, of course, to get to the remote, ice-bound colonies of the Emperor Penguin; you'll need an icebreaker and a lot of time. The reward, however, is an extraordinary, and unforgettable, experience. Emperors breed among towering cliffs of ice, a world of white and crystal blue. More than any other place I can imagine, it is like the surface of another planet. The penguins, meanwhile, are splendid emissaries from this distant world, always impeccably dressed.

From the rear, a Rockhopper's head plumes seem almost electrified. The five "crested" penguins, all similar in plumage, constitute the largest group of penguin species.

Adelie Penguins are true Antarctic penguins, and can be seen nowhere else. To many, these are the quintessential penguins, little men in tuxedos.

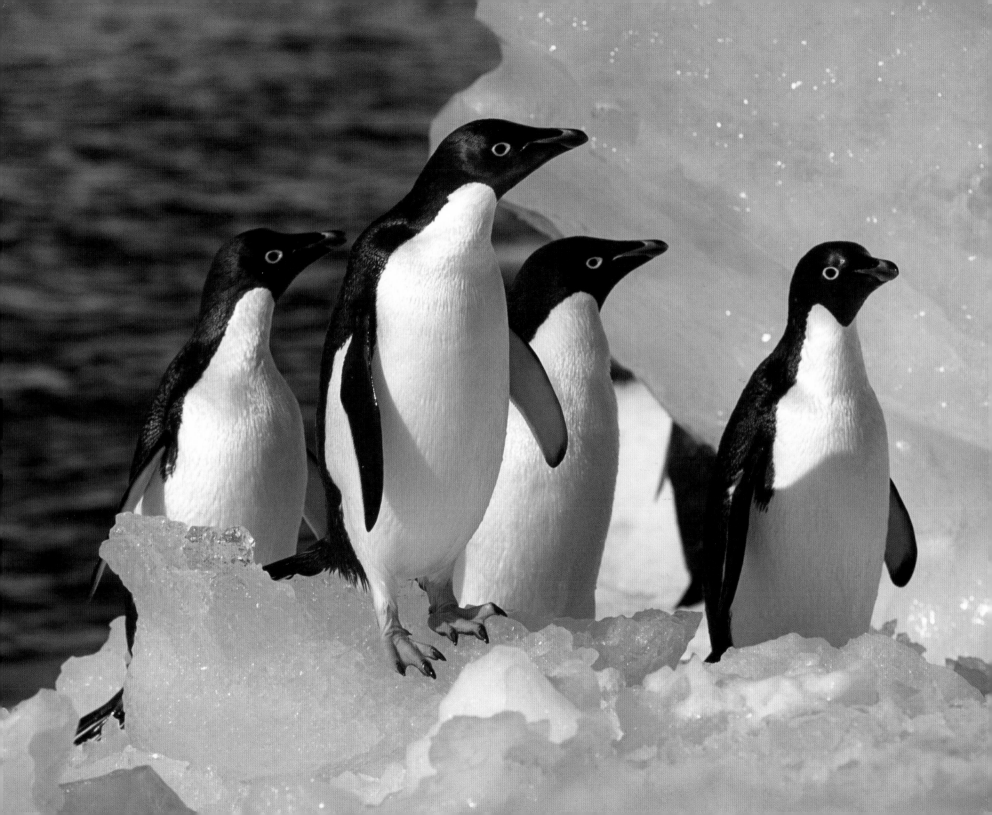

RANGE AND STATUS

THE GREAT PENGUINS: *APTENODYTES—"FLIGHTLESS DIVER"*

COMMON NAME	LATIN NAME	APPROX. SIZE	DIET	BREEDING RANGE	EST. POPULATION	STATUS
Emperor Penguin	Aptenodytes forsteri	115 cm (45")	Fish	Antarctica	425,000	Stable
King Penguin	Aptenodytes patagonicus	95 cm (37")	Fish	Sub-Antarctic Islands	3,000,000	Stable

THE BRUSH-TAILED PENGUINS: *PYGOSCELIS—"BOTTOM-LEGGED"*

COMMON NAME	LATIN NAME	APPROX. SIZE	DIET	BREEDING RANGE	EST. POPULATION	STATUS
Adelie Penguin	Pygoscelis adeliae	71 cm (28")	Krill	Antarctica	5,000,000	Stable
Chinstrap Penguin	Pygoscelis antarctica	77 cm (30")	Krill	Antarctic and sub-Antarctic	15,000,000	Stable
Gentoo Penguin	Pygoscelis papua	81 cm (32")	Fish, krill	Antarctic and sub-Antarctic	600,000	Stable

THE CRESTED PENGUINS: *EUDYPTES—"GOOD DIVER"*

COMMON NAME	LATIN NAME	APPROX. SIZE	DIET	BREEDING RANGE	EST. POPULATION	STATUS
Erect-crested Penguin	Eudyptes sclateri	69 cm (27")	Squid, shrimp	Bounty & Antipodes Islands, New Zealand	400,000	Vulnerable
Fiordland Penguin	Eudyptes pachyrhynchus	71 cm (28")	Squid, fish	South Island, New Zealand	5,500	Vulnerable
Macaroni Penguin	Eudyptes chrysolophus	68 cm (27")	Krill	Sub-Antarctic Islands	23,000,000	Vulnerable
Rockhopper Penguin	Eudyptes chrysocome	61 cm (24")	Krill	Sub-Antarctic Islands	3,000,000	Vulnerable
Royal Penguin	Eudyptes schlegeli	76 cm (30")	Krill, fish	Macquarie Island, Australia	1,700,000	Vulnerable
Snares Penguin	Eudyptes robustus	74 cm (29")	Shrimp, fish	Snares Island, New Zealand	46,000	Vulnerable

THE YELLOW-EYED PENGUIN: *MEGADYPTES—"LARGE DIVER"*

COMMON NAME	LATIN NAME	APPROX. SIZE	DIET	BREEDING RANGE	EST. POPULATION	STATUS
Yellow-eyed Penguin	Megadyptes antipodes	76 cm (30")	Fish	New Zealand	7,000	Vulnerable

THE BANDED PENGUINS: *SPHENISCUS—"WEDGE-LIKE"*

COMMON NAME	LATIN NAME	APPROX. SIZE	DIET	BREEDING RANGE	EST. POPULATION	STATUS
African Penguin	Spheniscus demersus	69 cm (27")	Fish	South Africa	180,000	Vulnerable
Galapagos Penguin	Spheniscus mendiculus	53 cm (21")	Small fish	Galapagos Islands	3,000	Endangered
Humboldt Penguin	Spheniscus humboldti	70 cm (27")	Fish	Peru, Chile	13,000	Vulnerable
Magellanic Penguin	Spheniscus magellanicus	76 cm (30")	Fish	Southern South America and Falkland Islands	2,000,000	Stable

THE LITTLE PENGUIN: *EUDYPTULA—"LITTLE GOOD DIVER"*

COMMON NAME	LATIN NAME	APPROX. SIZE	DIET	BREEDING RANGE	EST. POPULATION	STATUS
Little (or Blue) Penguin	Eudyptula minor	46 cm (18")	Small, fish	Australia, New Zealand	1,000,000	Stable

There is considerable variety in the kinds of place where penguins live—not just in the Antarctic. Penguins are found throughout the oceans of the Southern Hemisphere, along windswept desert coasts of Argentina and Peru, among dense rainforests of New Zealand, and in the Galapagos Islands—right on the equator.

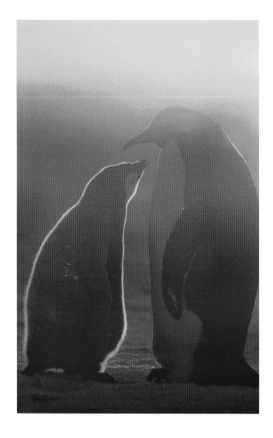

PHOTOGRAPHER'S NOTES

Photographing penguins does not generally require the long telephoto lenses or specialized equipment necessary for so much of wildlife photography. Short telephotos or wide angles are often much more useful, especially when trying to capture the beautiful landscapes in which most penguins live. Too many of us are content with "visual trophies," seeing close-ups as the ultimate prize when, in fact, a wider view often tells a more meaningful story.

Although penguins tend to be cooperative subjects, photographing them can be surprisingly difficult. Cold weather, rain, and snow can cause equipment—and photographers—to break down, and can result in gloomy, colorless pictures. Even worse, penguin colonies are among the filthiest, smelliest, and least inviting environments in which to work. They are also chaotic and full of distractions; for every perfectly posed penguin there are invariably two or three unwanted penguins standing in the background, ruining the picture. Getting a clean, uncluttered image in conditions like this can be almost impossible.

As a photographer, meanwhile, my greatest satisfaction comes from capturing unexpected behavior, moments that reveal something of the complexity—and the dignity—of my subject's life. With penguins, this is often easier than with other, less accepting animals. Nonetheless, capturing penguin behavior on film takes patience, good luck, and above all else, *time*. Simply said, time is a photographer's greatest ally: time to sit, wait, and observe, and if you're lucky, be ready when something unexpected occurs. That's when memorable pictures happen.

As for equipment, my usual "penguin paraphernalia" consists of two to three Nikon digital camera bodies and some assortment of the following lenses:

17–35 mm zoom

24–70 mm zoom

70–200 mm zoom

200–400 mm zoom

60 mm or 105 mm macro

300 mm telephoto

Although I shoot with digital cameras exclusively now, many of the older pictures in this book were taken with a variety of film cameras. I was rather slow to make the transition to digital, having dedicated myself for two decades to the goal of producing the perfect color transparency. And although it may seem anachronistic, I still miss the thrill of opening a box of slides on a light table to discover the treasures inside.

I generally carry a tripod to help steady my camera, but when events are happening quickly, I find I rarely use it. At times like those, I much prefer to shoot fast and low, often lying down to get an eye-level "penguin perspective." (Far too many people take their pictures from a standing human viewpoint, literally looking down on their subjects.) The drawback of getting eye-level pictures, of course, is the foul slime you sometimes have to crawl through to take them.

And finally, a word about reality and ethics: photography has undergone a true revolution over the course of my career as film has been replaced by digital media and computers have expanded the creative process far beyond the limitations of the original exposure. At one time, clicking the camera's shutter was the last step in the process. Now, instead, computers invariably have the last word, inviting manipulation and exaggeration. In my view, the "wow" factor of photography—its power to delight and even astonish—is directly tied to its being perceived an honest record of a real event. Without that, a picture is just an illustration, and truth is irrelevant.

SUGGESTED READING AND ORGANIZATIONS

There are many books available on penguins, some scientific, some popular. Many of those listed here were helpful to me in creating this book, and can provide much more information for readers with a special interest in penguins. There are also an increasing number of online resources available with good information on penguins.

Robert Cushman Murphy, *Logbook for Grace*, Time-Life Books, 1965, 374 pp.
> A delightful account of a journey by a young naturalist to South Georgia in 1912 aboard one of the last whaling ships working under sail. Full of descriptions of penguins, albatross, and other Antarctic wildlife.

Ron Naveen, *Waiting to Fly*, William Morrow, 1999, 374 pp.
> A wonderful blend of obsession and science. A colorful and informative tale of the Antarctic penguins, by someone who has devoted his life to their survival.

George Gaylord Simpson, *Penguins: Past and Present, Here and There*, Yale University Press, 1976, 150 pp.
> The best source of information on the evolution of penguins, by a renowned paleontologist and admitted "penguin addict."

Tony D. Williams, *The Penguins*, Oxford University, 1995, 296 pp.

An in-depth collection of information on all of the world's penguin species: an essential resource for penguin lovers.

And finally, a very useful online source of penguin information.

www.penguinscience.com: science-based resource on penguins, with special attention to climate change.

There are also a number of organizations that are working to protect penguins—and the marine environment in general. Among these are

Falklands Conservation

1 Princes Avenue

Finchley, London N3 2DA

United Kingdom

http://www.falklandsconservation.com

Working to protect this spectacular collection of islands and their wildlife—including large colonies of breeding penguins.

Wildlife Conservation Society

2300 Southern Blvd.

Bronx NY 10460

http://www.wcs.org/

Among its many projects, WCS sponsors important work to protect the Magellanic Penguin in Patagonia.

Center for Marine Conservation

 1725 DeSales Street, N.W. Suite 600

 Washington, DC 20036

 http://www.cmc-ocean.org/

 CMC works to protect the marine ecosystem worldwide and has long been involved in protection of the Antarctic ecosystem.

South Georgia Heritage Trust

 Verdant Works

 West Henderson's Wynd

 Dundee DD1 5BT Scotland

 http://www.sght.org/Habitat-Restoration

 The South Georgia Heritage Trust has committed itself to eradicating rats on this spectacular island. If it is successful it will be the single greatest achievement to protect nesting seabirds ever made.

INDEX